KIRKBY
& DISTRICT
From Old Photographs

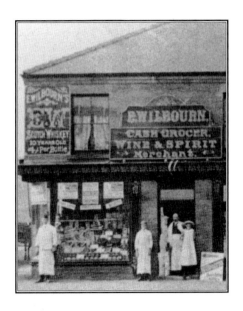

KIRKBY
& DISTRICT
From Old Photographs

FRANK ASHLEY, SYLVIA SINFIELD
& GERALD LEE

AMBERLEY

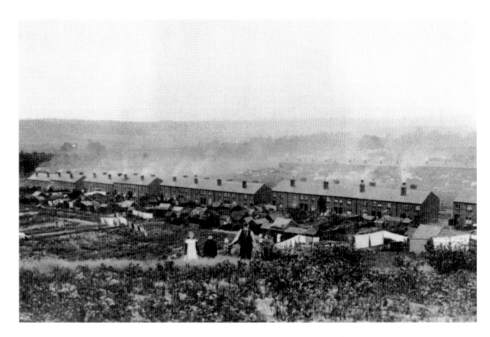

Miners' cottages, Annesley Rows, 1914.

This edition first published 2010

Amberley Publishing Plc
Cirencester Road, Chalford,
Stroud, Gloucestershire, GL6 8PE

www.amberley-books.com

British Library Cataloguing in Publication Data.
A catalogue record for this book is available from the British
Library.

ISBN 978 1 4456 0141 0

Typesetting and Origination by Amberley Publishing.
Printed in Great Britain.

Contents

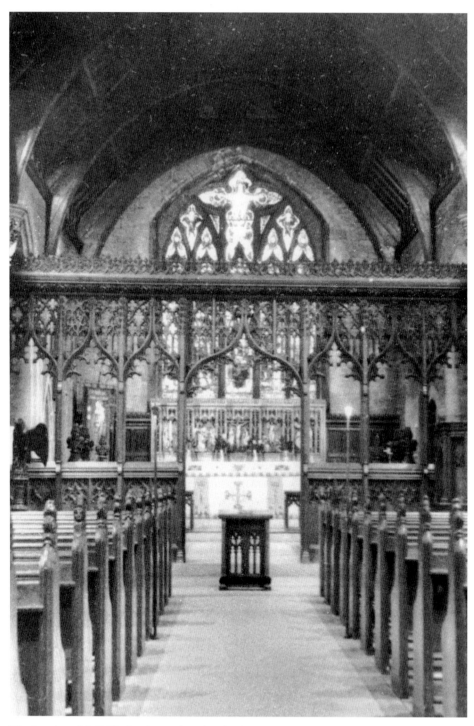

The interior of St Wilfrid's, the mother church of Kirkby-in-Ashfield, lovingly restored after the fire of 1907; note the beautiful oak pews and screen, and beyond, the exquisitely carved reredos and impressive east window.

Introduction

In conversation with a friend who lived in a city suburb I was struck forcibly by one remark: 'I have lived in this place for more than ten years, and yet I know only three of my neighbours.' I realised how lucky some of us are to live in communities where we can walk down almost any local street and meet someone we know well enough to talk to. Kirkby-in-Ashfield is such a place. Find it on the map and it looks insignificant enough; but live there for any length of time, read about it, talk to those who know it, and you will soon realise it is steeped in history, part of the rich tapestry of Nottinghamshire.

For long years – centuries, I suppose – it was mainly agricultural, its inhabitants used to what we imagine was a slow and sleepy way of life, with little excitement except at seedtime and harvest. But for those whose livelihood depended upon those two major seasons plenty was happening, and mighty hard life must have been. The district contained two neighbouring villages: Kirkby-in-Ashfield, all tiny dwellings apart from the old manor house and a few well stocked farms; and East Kirkby, growing up round the Nag's Head. Many who were around when that hostelry was built said it was nothing but a folly, and that the village would never be able to support it. 'The Folly', in fact, was the name by which East Kirkby was known by the locals for many years.

For a long time, what few alterations there were must have been scarcely noticed; and the combined population inched its way to around seven thousand, and seemed set to stay there. But in the late years of the last century the twin villages were transformed by industrial development, and the gentle contours of the land were disturbed as pit shafts were sunk and mining started. Suddenly the outlook for Kirkby-in-Ashfield, East Kirkby and the outlying hamlets was bright – or bleak, according to how you viewed it. But whatever your place in the community a new day had dawned, and the time was not far distant when you could stand on Boar's Hill looking towards the Derbyshire border and count a handful of collieries, knowing there were three more in the other direction.

With the advent of mining came the railways, and very soon the seven thousand who lived in the district found their numbers increasing; so much so that in the next thirty years the population reached seventeen thousand. The railways gave access to formerly distant places, and horizons began to widen. Gradually the region became comparatively prosperous.

Not that prosperity made life any easier. Mining was never easy but it played an important role in strengthening the community spirit that both the Kirkbys had always known. The miners worked hard and they played hard; and because they spent so many hours beneath the fields, they took outdoor recreation when their working day was ended. It is part of sporting history that many a miner played his way to fame with bat and ball.

Scars left by the strikes in the 1920s were slow to heal, but the sense of community remained, with a constant striving for improved conditions and better education. There were some memorable teachers who worked mightily to polish native talent. There is dedicated teaching still, all through the age range, and Kirkby-in-Ashfield now has comprehensive schools at either end of the town.

For decades, through both good times and bad, there has been religious activity – during one well-remembered period the churches and chapels were packed every Sunday. Sadly, however, the march of progress, if progress it can be called, has dampened much of the fervour; one can only wonder what the years ahead will bring.

East Kirkby's name has now disappeared, and the two villages have become a single town. Although the pits have gone (apart from the enthusiastic reopening of Annesley Bentinck Colliery in April 1995), and the efficient railway service became a casualty of the Beeching closures, new industries have arrived to take their place. Most have survived recent difficulties and are poised for the return of prosperous times; the work on the extension of the Robin Hood line should restore a sense of railway glory.

Yet there is a timelessness about Kirkby that absorbs changes, and the golden vein of sturdy local character has remained constant through the centuries. When one looks at Kirkby's old Market Cross (a market and fair were granted as early as 1261), and then walks on to the parish church of St Wilfrid – and reminds oneself that there has been a church there since Saxon times – we may believe that that sturdiness of character, and the Christian tradition that moulded it, will happily prosper for many years to come.

G. A. Lee

one

Days to Remember

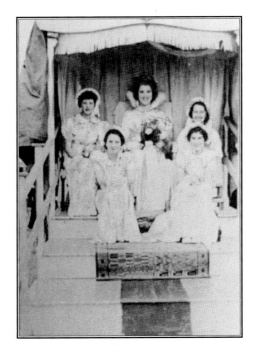

Carnival festivities, 1939.

Winifred, Duchess of Portland, pictured shortly after opening a Christmas bazaar at St Andrew's Church in 1951. The vicar at the time was the Revd Sidney Butler.

Forest Street Baptist Ladies about to set off for a day's outing, 1930s.

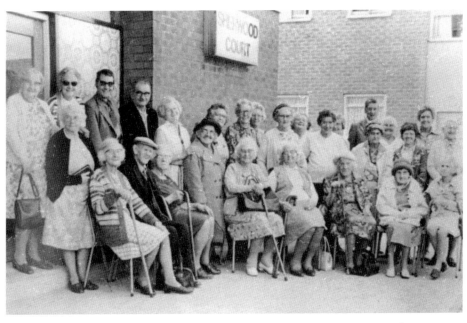

House-bound members of the Luncheon Club outside Sherwood Court, 1980s. Their meetings were held first in the Roman Catholic Church Hall and later at Sherwood Court.

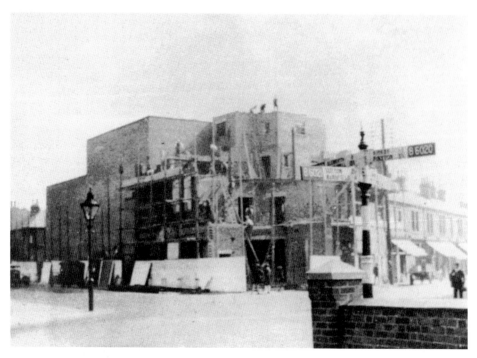

The Regent Cinema under construction in 1928. The cinema opened on 6 October 1930; the first film shown was *The Desert Song* starring John Bowles. The Regent enjoyed great success for thirty-five years and is now a popular restaurant.

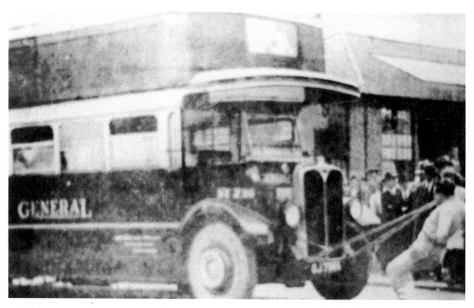

Saxon Brown, billed as 'the World's Strongest Man', pulling a Midland General bus – with his teeth! Saxon was the main attraction for a week in 1932 at the Kings cinema, his act being staged nightly between the first and second houses.

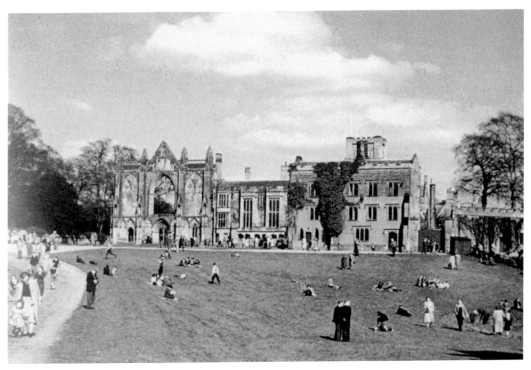

A summer day at Newstead Abbey. This historic house, once the home of the poet Lord Byron, remains popular with visitors. The photograph above shows the Abbey from the lawn, with below, the stables viewed from the top of the waterfall across the upper lake.

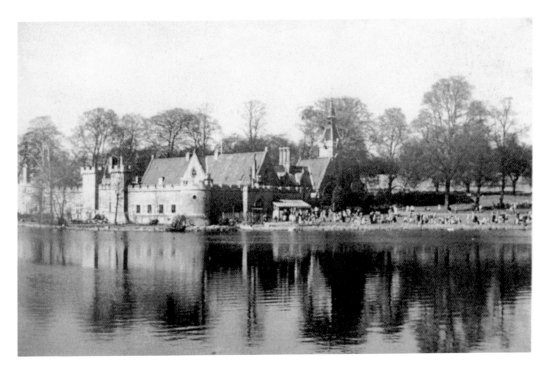

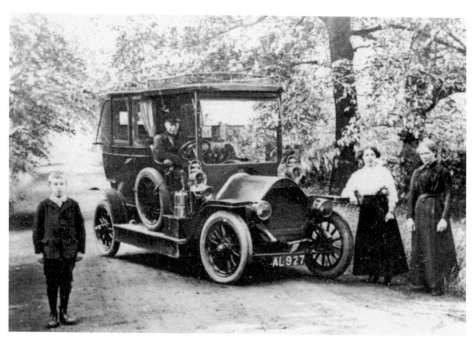

Posing with Mrs Salmond's Beeston Humber car on Langton Hall drive are groom/chauffeur George Woolley, his wife, daughter Annie and son Billy.

Greensmith was one of the earliest Kirkby names to be connected with the motor trade. Here two of the Greensmith children – Ivan in the driving seat and Lewis in front – are posing in a 1910 Rexette forecar.

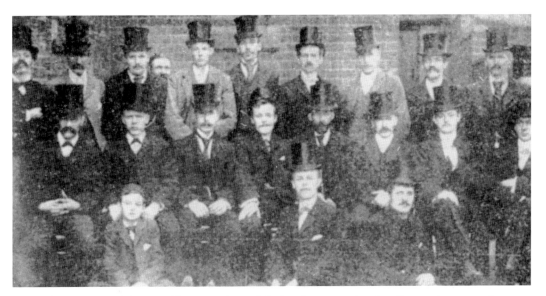

The Nuncargate Top Hat Glee Party. Formed during the 1893 miners' strike to raise money for relief work, the choir became so popular that it was in demand for a number of years. The singers are shown before giving a concert at the old Wesleyan Chapel, Annesley Woodhouse.

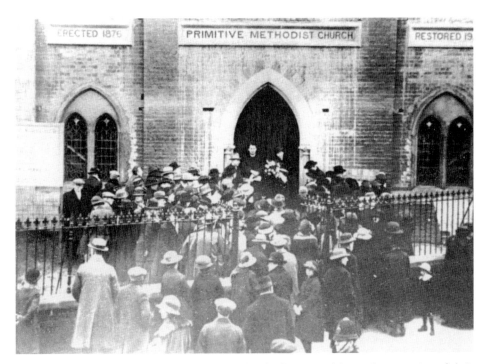

Members of the Bourne Primitive Methodist Church about to celebrate the reopening of their premises after restoration in 1924. Although the Lowmoor Road church continued for many years it was eventually amalgamated with Diamond Avenue Trinity Methodist Church.

In 1951, as the country was getting back into full production after the Second World War, a Festival of Britain exhibition was held in the newly rebuilt and appropriately renamed Festival Hall. It was formerly called the Market Hall, where stallholders plied their wares each weekend. Then, as now, it was much in demand for recreational activities.

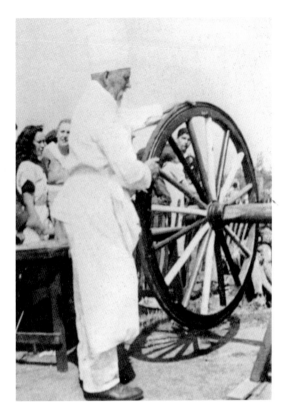

Celebrated ox roaster Fred Tyler
(right) of Stratford-upon-Avon, in
action at the first Kirkby Carnival,
1935. Mr Tyler was booked for
the occasion by Kirkby butchers,
fourteen of whom had subscribed
to buy the ox. The first slice from
the roast (below) was auctioned,
and sandwiches were made from
subsequent cuts and were eagerly
purchased by the large crowd gathered
on Kingsway Park.

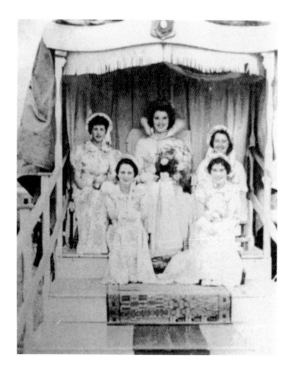

With the Second World War only months away, the town nevertheless enjoyed its summer festivities in 1939. The Carnival Queen was Miss Ivy Bradshaw; her Maids of Honour (left to right) were: Misses Dorothy Wood, Pearl Topham, Nancy Broadley and Joyce Coleman.

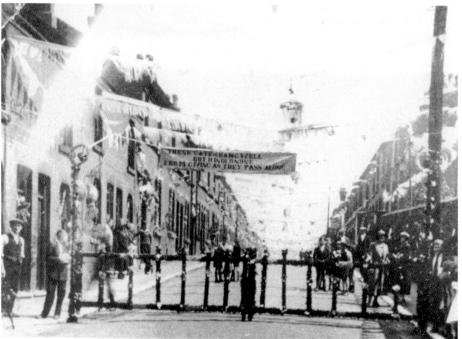

There was always tremendous competition for the accolade of best decorated street at Carnival time. The banner displayed in Unity Street in 1936 reminded all who came to view of the purpose of the barrier: 'These gates hang well but hinder none from giving as they pass along.' The proceeds from Kirkby's Carnivals went to the Mansfield and Nottingham hospitals.

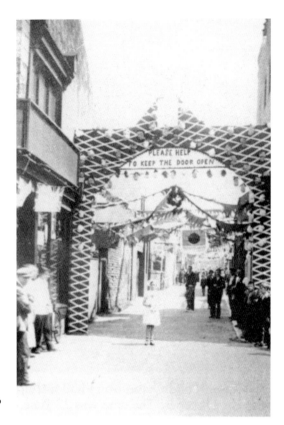

Byron Street was another that was always in the forefront when it came to decorations.

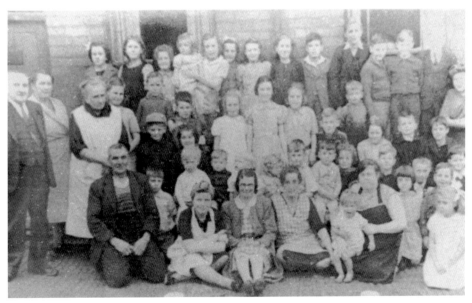

Jack Tatton (kneeling) surrounded by some of the Byron Street residents. Between the wars, Jack was one of Kirkby's characters, going about his business as a chimney sweep, but between times doing yeoman service as the Town Crier. He could be heard from a considerable distance!

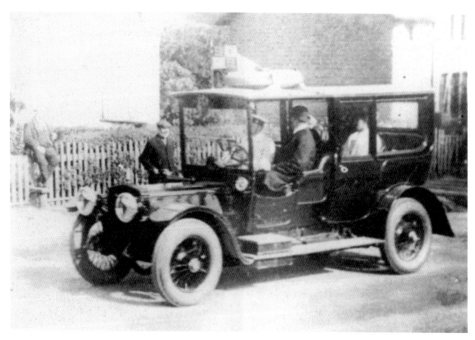

King George V and Queen Mary had just driven through Annesley Park on their way to stay in the Dukeries. The date was 25 June 1914. A few weeks later war was declared, and the world changed for ever.

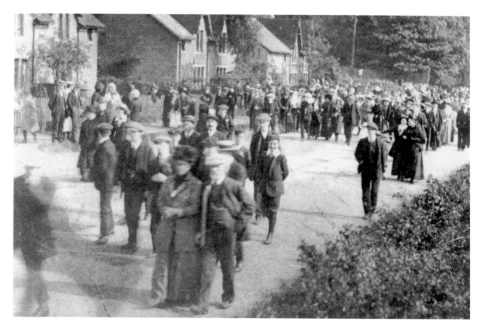

A large crowd turned out to see the Royal visitors. Despite the fact it was high summer, the clothing could hardly have been more sober. Royal visits apparently called for the wearing of one's Sunday best.

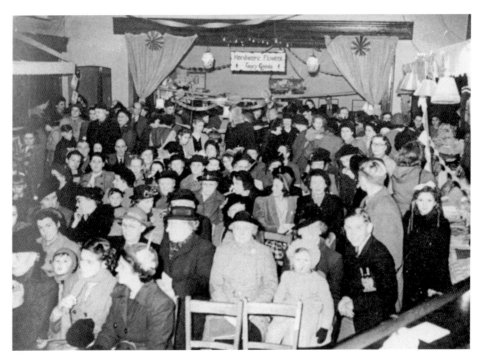

A packed crowd in the old St Thomas's Church Hall waiting for the opening of a Christmas bazaar.

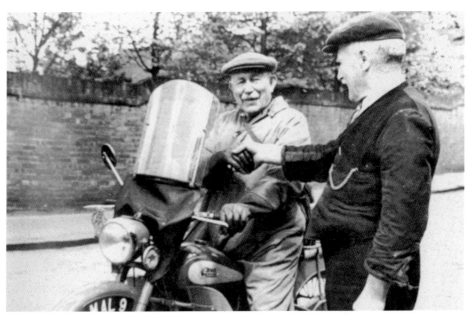

Mr Lane, aged eighty-two, about to start on his round trip from St John's Avenue to Land's End, thence to John o' Groats and back to Kirkby. His object was to prove that elderly motorcyclists were competent to make such arduous rides in the 1950s. His friend Mr Winston is shown wishing him good luck.

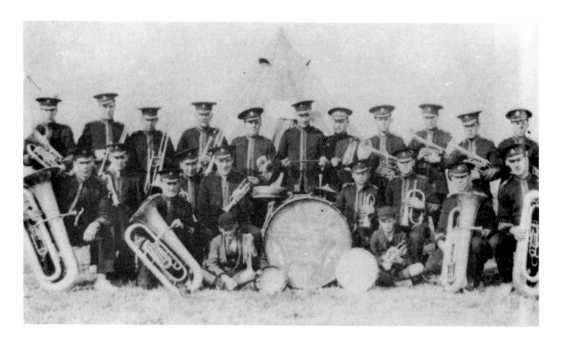

For many years Kirkby Old Band played its way to an enviable reputation. The photograph above shows the band in camp at Mablethorpe in 1927, where they were taking part in a contest. At that time steady progress was being made towards some notable successes, none more widely acclaimed than the prizes carried off at the *Daily Herald* Championships at Manchester's Belle Vue. Below we see the band at a rehearsal in their early days, no doubt enlivening the neighbourhood's Sunday morning.

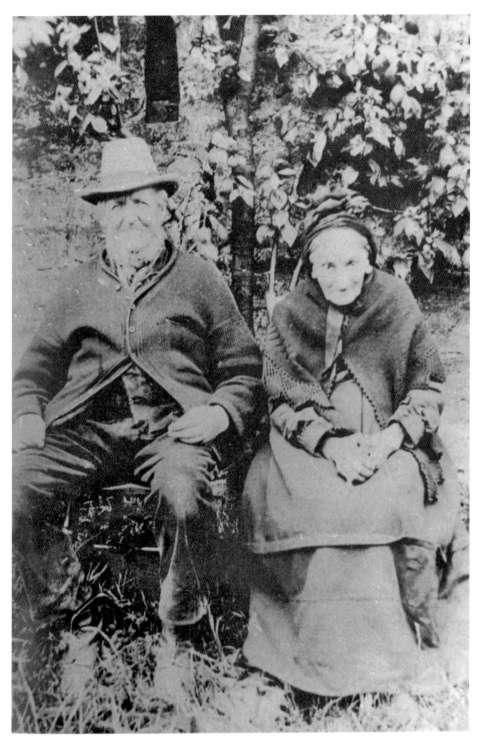

An old lady and gentleman in the garden of their house at Annesley Woodhouse. The photograph is thought to be the work of Mr Owston and is well over a hundred years old.

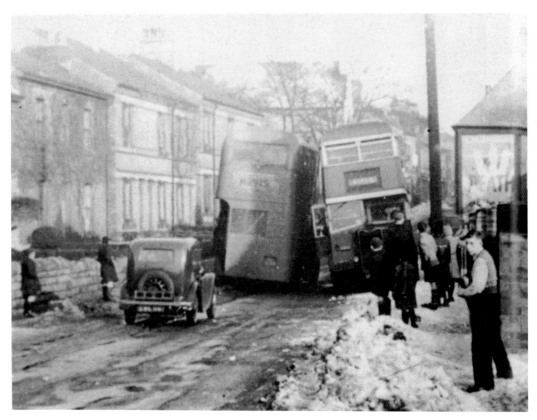

Excitement on a snowbound day in the winter of 1952/3 as two buses, a Trent and a Midland General, attempt to pass at the foot of The Hill. (Historically, this incline was known as Cock-at-Hill.) Was the car parked, making the manoeuvre more hazardous? Or was the driver hoping eventually to proceed?

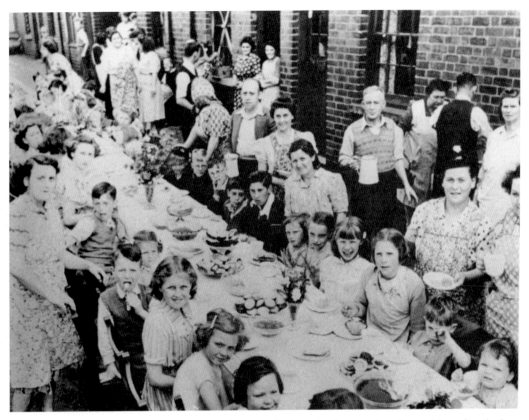

A party held in New Street to celebrate the Festival of Britain. It was a time for rejoicing after the long years of the Second World War.

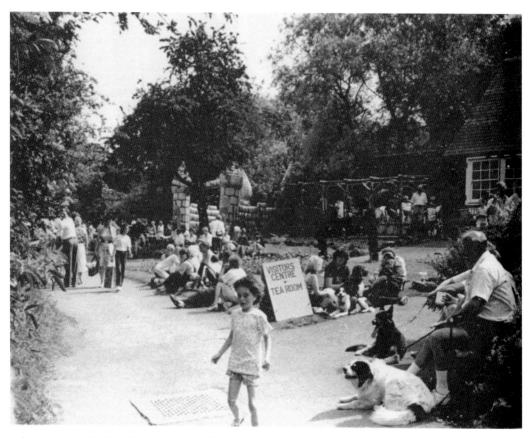

A happy day in Portland Park before the disastrous fire on 18 October 1992. A splendid new Visitors' Centre was opened in 1994, largely through the efforts of Kirkby's conservationists.

two

Rural Reminders

Portland Park, c. 1905.

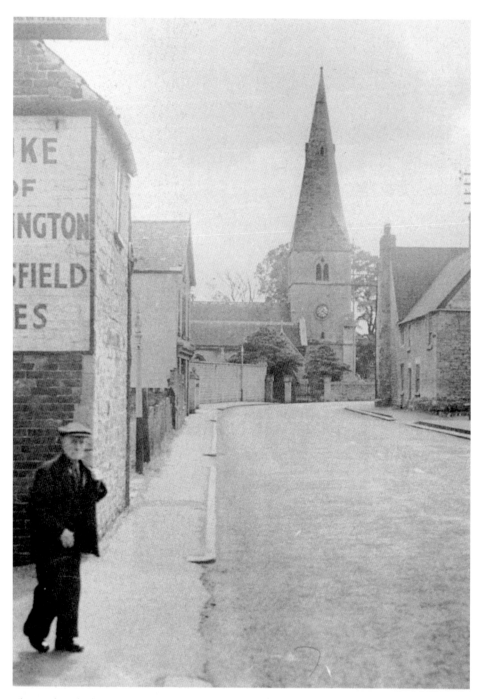

The south end of Church Street at a time when St Wilfrid's worshippers were mainly pedestrians. Later the Rectory garden wall was demolished so that a much-needed car park could be made. The building on the far left was a shop; opposite was the end wall of the Manor House beside Manor House Farm. Both these ancient buildings were pulled down in the early 1960s to make way for a new housing development.

A leafy glade in Portland Park in the early years of the century.

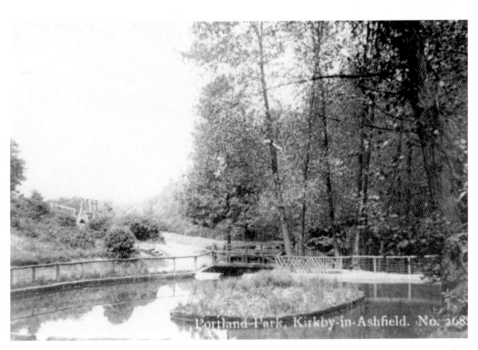

The lake in the Park, c. 1930. This area, much overgrown and neglected for many years, has been brought to life again through the efforts of the Kirkby and District Conservation Society volunteers.

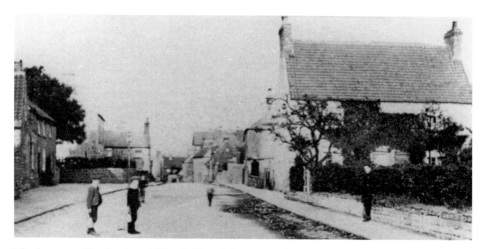

The boys standing in the middle of Chapel Street could watch the photographer undisturbed. Picturesque cottages stand on either side of the street, and further down on the right, opposite Beeley's Farm, stands Chapel Street School. Sherwood House Inn, known locally as 'The Thack', is the high building on the right in the distance.

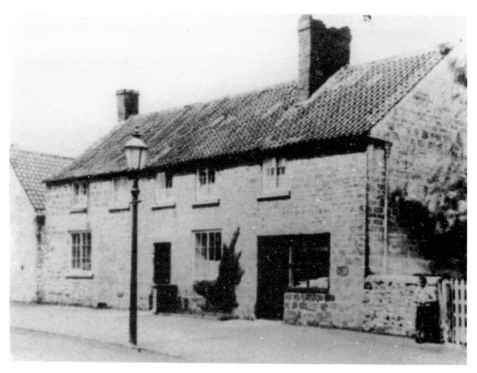

Broom House was for a long time the home of the Misses Fox, one of whom was a noted herbalist. The shop window on the right was the front of an adjacent cottage, which later became part of Mr Baden Powell's motor repair business: this was built up against the right gable end.

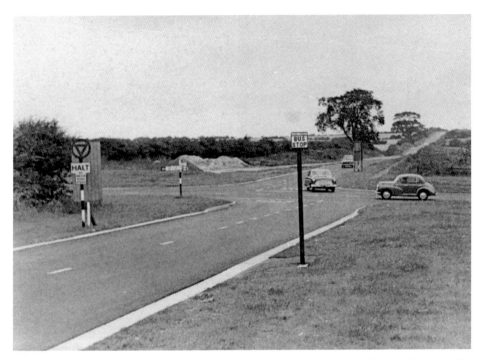

The Coxmoor crossroads, *c.* 1965. They were still well out in the country then, with the road in the distance running between attractive Thieves' and Nomanshill Woods.

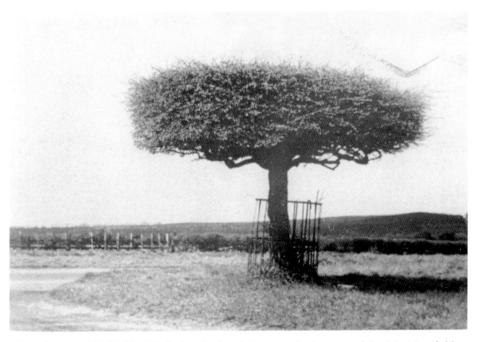

The aptly named 'Table Top Tree', close by Larch Farm, at the junction of the A60 Mansfield to Nottingham road and the quiet lane leading to Blidworth via Fountain Dale.

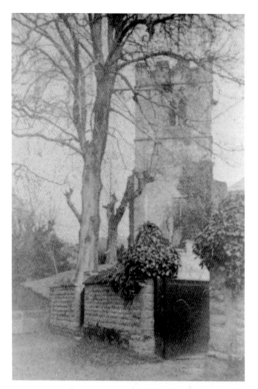

The old church next to Annesley Hall was the parish church until the colliery village was built about a mile away. The new All Saints' Church was built on a hill close to the mining community.

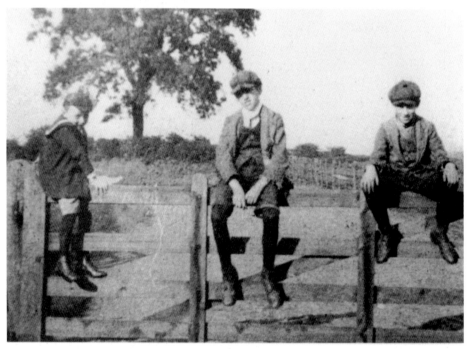

Three lads take a breather in spacious country days. Sunshine there might be, but it seems thick clothing – and knickerbockers – were the order of the day.

Cowpasture Lane, looking towards Sutton Road. On summer weekends, particularly between the wars, the lane was a favourite walk. It led to the Cowpastures, then a huge expanse of common grazing land with extensive views into Derbyshire.

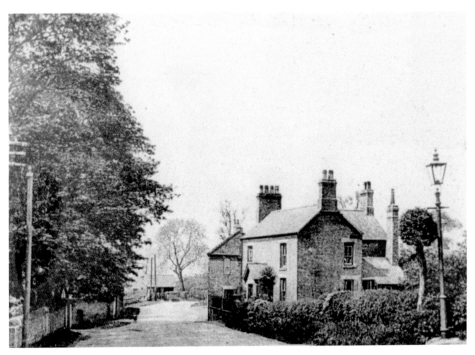

Selston Lane, Annesley Woodhouse. It was a long and lonely walk between the two villages.

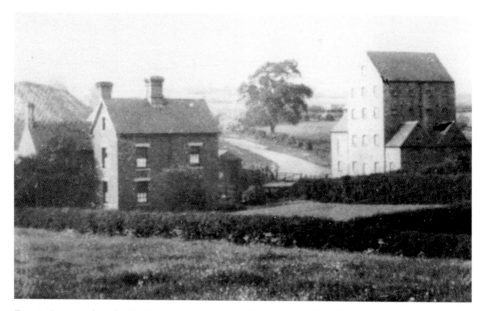

Fryer's Farm and Mill. The Mill, between Kirkby Bentinck and Kirkby Woodhouse, was owned by the Fryer family for almost two hundred years until the tenancy passed to Mr William Curtis, a well-known Kirkby butcher, in the 1930s. Both the mill and farm are no more, the mill having been demolished in 1930 and the farm in the late 1950s.

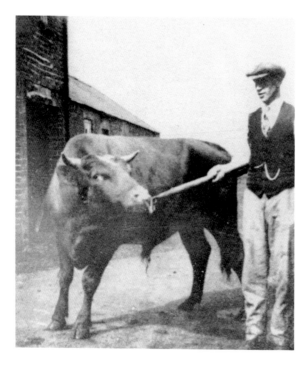

A worker at Fryer's Farm, skilfully handling a bull in the early days of the twentieth century.

St Wilfrid's and the Old Rectory from across Hockley Valley. This view was much admired by the artist Samuel Grimm, friend of Sir Richard Kaye, Rector of Kirkby from 1765 to 1783.

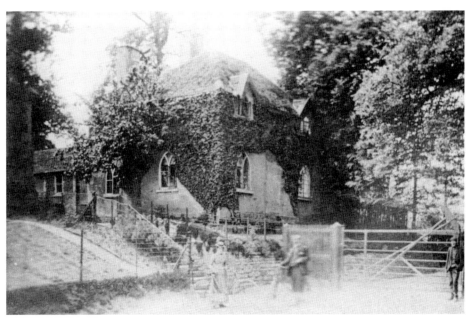

Annesley Park was for years a stately drive with toll-gates at either end. This is the south toll-gate, beside which stood this attractive, creeper-covered house.

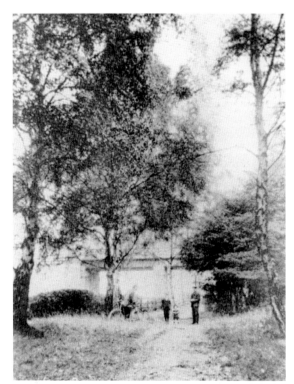

An entrance to 'Kirkby Quarries', a local nickname for Portland Park. This lay along one of the earliest industrial embankments in the county, that of the Mansfield and Pinxton Railway line of 1817. The Great Central Railway bridge in the background carried a tremendous amount of traffic, both passenger and freight.

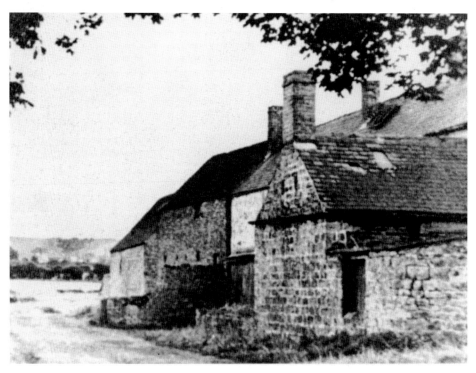

Grives Farm at the east end of Portland Park has changed little over the years.

The pinfold at the top of Church Hill offers a reminder of Kirkby's agricultural past. Stray animals were kept in the pinfold until their owners collected them.

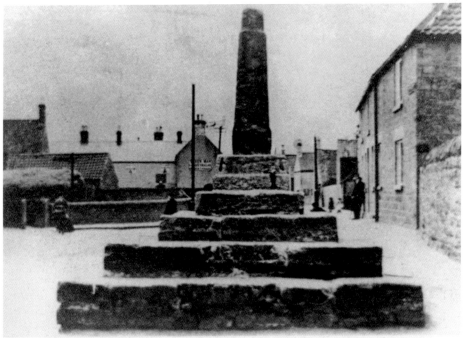

Kirkby's ancient Cross. The village was granted a market and fair in 1261. Behind the monument can be seen the Green Man, once a well-known hostelry. To the left of the Green Man on the corner of Church Street and Chapel Street lived Mr Arthur Brailsford, headmaster at Selston, and for years a stalwart of Kirkby Saddle Club.

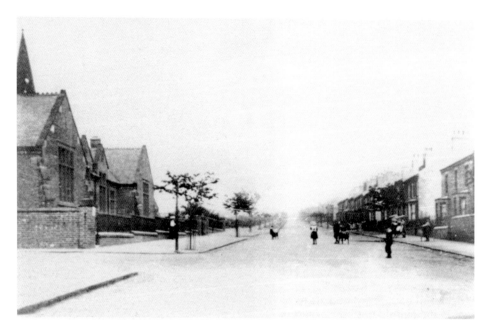

It is a long time since pedestrians could walk without danger down the middle of Diamond Avenue! Directly opposite the school was the house of Dr McCombie, who practised in Kirkby for many years.

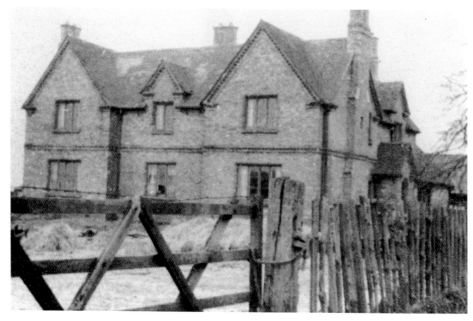

Formerly the Musters Arms on Forest Road, Annesley Woodhouse. Later it became Fisher's farmhouse, with a small butcher's shop to the right of the porch. The building was demolished in the 1960s.

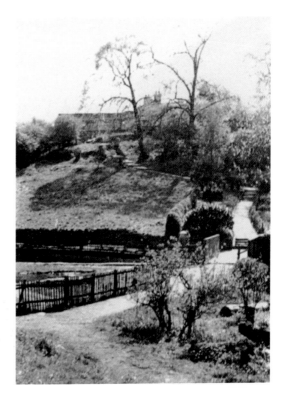

A quiet morning in Portland Park. The path climbs between Lake Victoria (named after Lady Victoria Cavendish-Bentinck) and the largely obscured paddling pool. This place was greatly favoured by children in the long summer holidays.

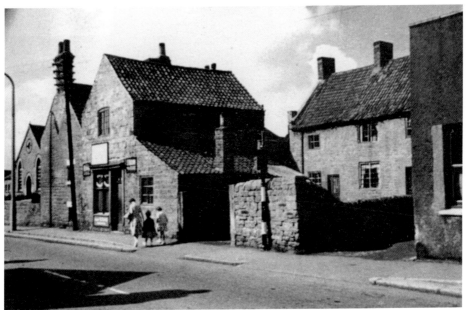

Church Street, showing the old post office and the fruit and confectionery business run by Mr and Mrs Wightman. Post office transactions were carried out in the lean-to section of the building. Adjacent to Wightman's is Rose Cottage, and beyond is St Wilfrid's Parish Hall, which was completely modernised in the early 1960s.

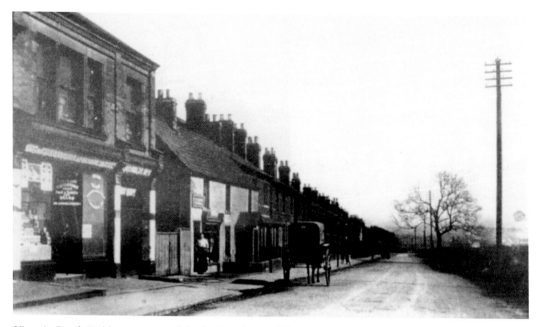

Victoria Road, Kirkby, now one of the busiest thoroughfares in the district, shown in days of greater tranquillity in around 1910. Council houses now line the right-hand side of the road. The tree in the distance was enormous and had to be uprooted by a steamroller pulling on a chain locked around the trunk.

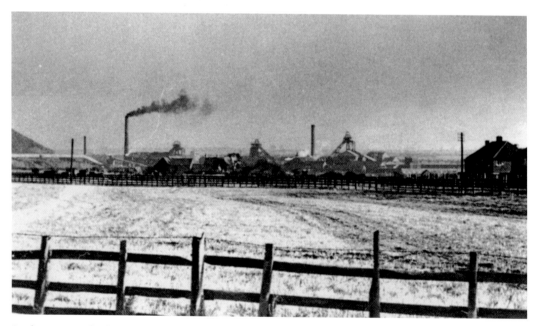

Looking across the fields towards Summit Colliery from Sutton Middle Lane. Before this area was built up soon after the Second World War it was possible to walk more than two miles between high hedges almost all the way to Sutton.

three

Horse Power

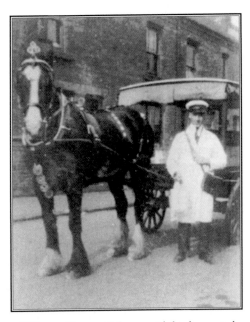

Milkman George Pickaver with his horse and dray, 1930s.

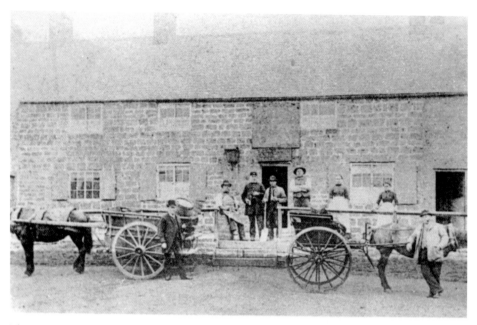

The Railway Inn in 1892 when Kirkby's population was around seven thousand. At that time photography was more complex than just pressing a camera button, and one wonders how long the characters had been posing. During the next thirty years, the district was to be transformed, largely through the mining industry, and the population increased by more than ten thousand.

A greengrocer on his round at the bottom of Church Hill, c. 1900. Church Hill was one of several unmade roads in the district.

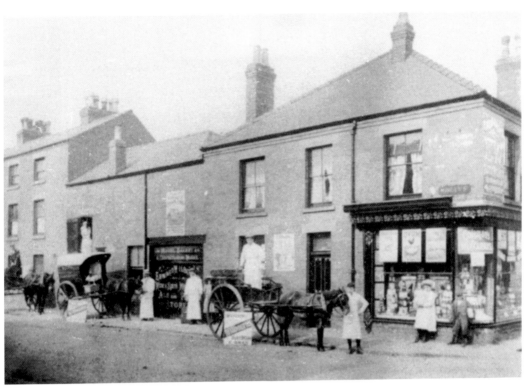

Wilbourn's team of horse-drawn carts being loaded for the day's deliveries.

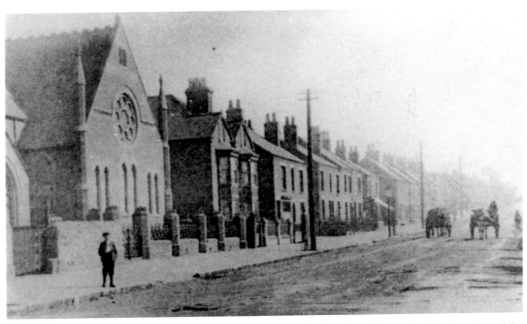

Horses and carts on Diamond Avenue, 1910. Trinity Methodist Church is on the left. A number of the properties further along have been demolished, but several of the old cottages are still there.

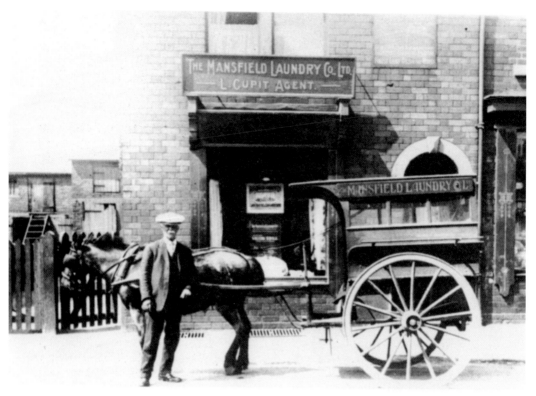

Mr L. Cupit, photographed outside his Mansfield Laundry agency on Lowmoor Road, about to set off on his rounds. The shop later became the premises of E. A. Cresswell Ltd, wholesale and retail tobacconists.

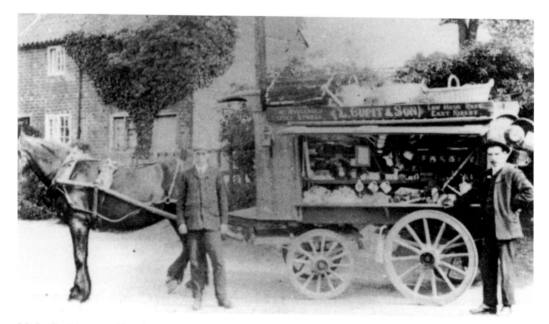

Mr L. Cupit's sons selling hardware from their mobile shop.

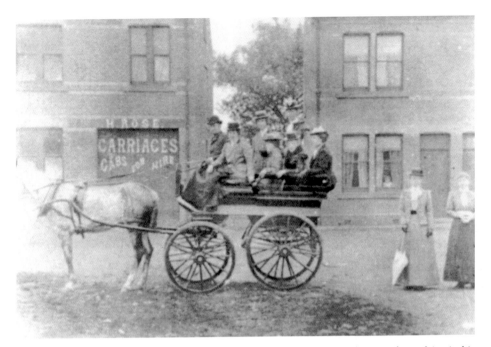

Kingsley Street, *c.* 1900. Henry Rose is ready to take the six Copeland sisters for a drive in his wagonette. His wife, Mary Ann Rose, stands on the right with her two nieces, Bella Cooper and Clara Moore. The building advertising carriages and cabs for hire became, much later, Stirland's Garage.

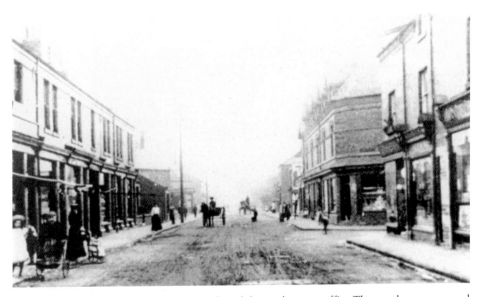

The shops on Cemetery Road long outlasted horse-drawn traffic. The road was renamed Kingsway after the visit of King George V and Queen Mary in 1929. It was not significantly modernised until many years later.

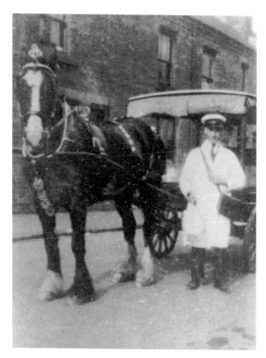

George Pickaver, long-service milkman with the Co-op Dairies, 1930s. At this time there was keen competition for the best turned-out horse and dray.

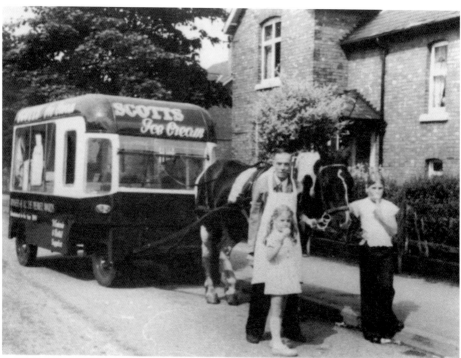

Scotts were well-known ice cream makers in Sutton until 1975. Vic Clay Fox, the salesman in the photograph, was often seen around Kirkby with his horse Patch and van. He is shown here on Marlborough Road with two appreciative customers.

four

An Age of Coal and Steam

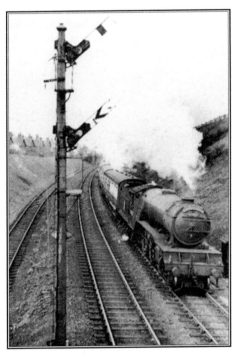

The South Yorkshireman *near Kirkby Bentinck
station.*

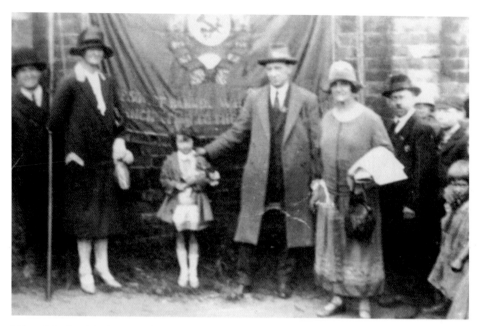

Miners' leader Mr A. J. Cook, accompanied by his wife, before addressing a miners' rally on the Pondhole in 1926. The banner was a gift to British miners from their Russian colleagues. On the left is Billy Duffin, at that time Kirkby's Town Crier.

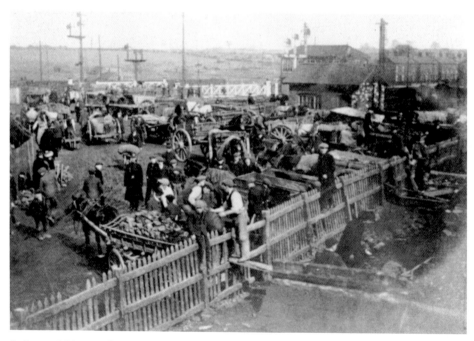

Strikers picking coal near Summit Colliery, 1926. A policeman keeps a watchful eye on proceedings.

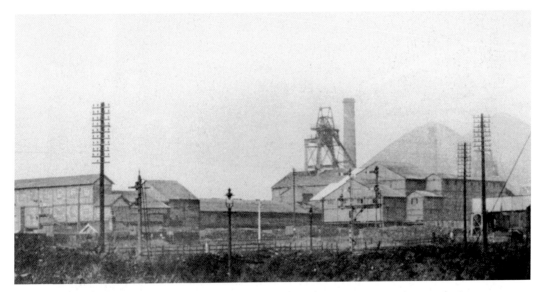

Summit Colliery was a vital part of Kirkby for over eighty years, at one time employing more than 1,500 men. Before its closure in 1969 well in excess of a million tons were mined in one year, and there were plans to make it one of Europe's showpiece collieries. In the 1920s and '30s the end of the day shift was a memorable sight as hundreds of miners tramped home, their snap-tins and dudleys (sandwich boxes and water bottles) swinging from their belts.

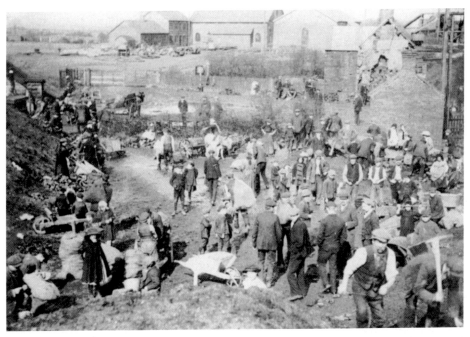

The 1926 miners' strike meant coal was in short supply even for those whose livelihood depended on its production. These colliers are scrabbling for coal among the slag-heaps during the long days of privation.

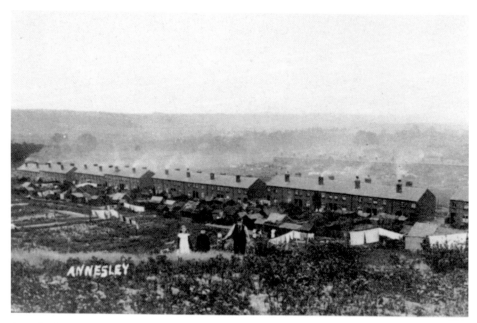

Annesley Rows, 1914. These houses were built for miners employed at the nearby colliery. Behind the nearest row of dwellings was an extensive area of land used as garden allotments, with plenty of room to hang out the weekly wash.

Some of the earliest members of the Diamond Avenue Working Men's Club, an establishment still flourishing after considerable refurbishment over the years.

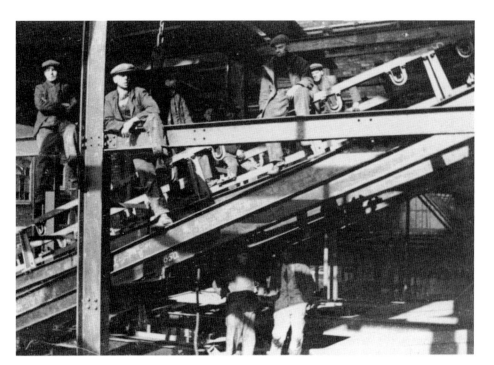

The contractor's men employed in the construction of the new washery at Summit Colliery posing for the photographer.

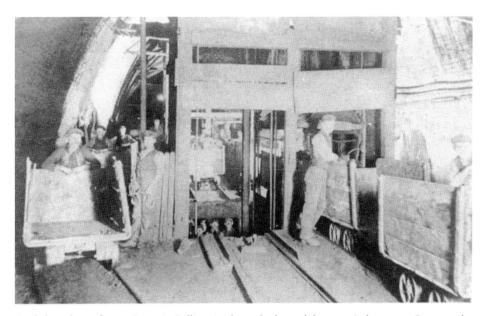

Far below the surface at Summit Colliery in the early days of the twentieth century. Between the rails for the tubs miners can be seen in the cage descending to the pit bottom. The colliery was sunk late in the nineteenth century on land bought by the Butterley Company in 1887.

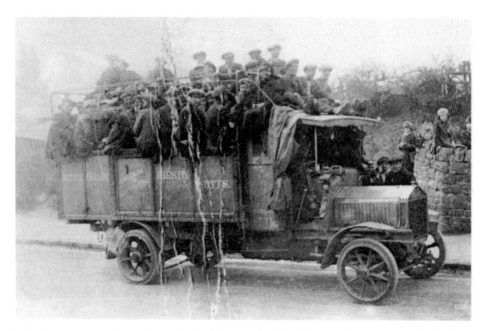

Haulage contractor Arthur Garner's 'Paddy Bus' for the miners working at Bentinck Colliery, photographed at the top of Church Hill, 1910. Looking at the number of men aboard and knowing the gradient of the hill, one can only say the solid-tyred lorry had done very well!

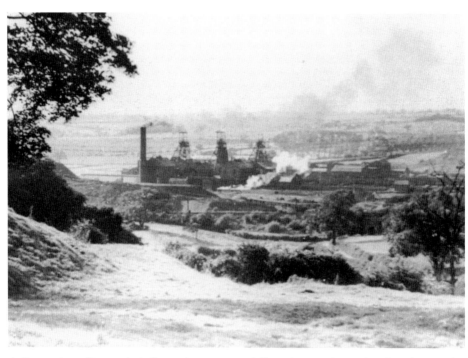

A distant view of Bentinck Colliery when it was in full production, from Chapel Bank, Annesley Woodhouse.

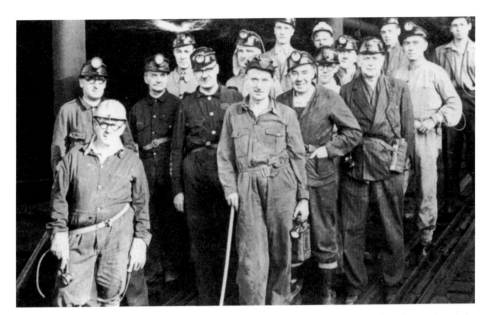

Air pollution from Summit Colliery and the nearby locomotive sheds caused such a nuisance in the 1950s that Lowmoor Road residents formed a Smoke Abatement Society. Led by Councillor Arthur Mead, the Society campaigned for a reduction in atmospheric pollution. Here, members are about to learn at first hand about coal production at Summit Colliery.

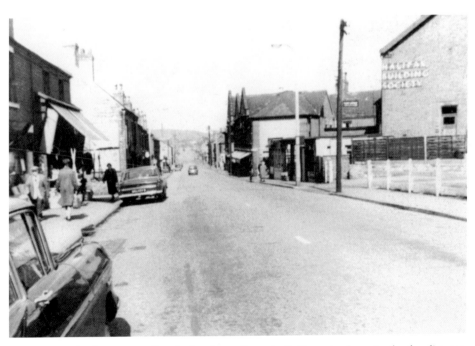

The north end of Lowmoor Road, showing a Summit Colliery slag-heap in the far distance, c. 1960. The shop of Briggs and Hague is on the left, and on the right the office of accountant Howard Johnson, who was also an agent for the Halifax Building Society.

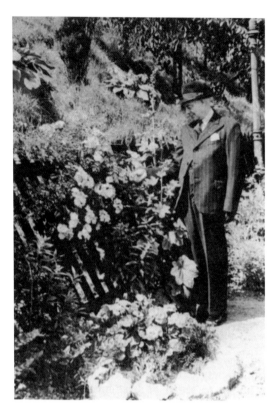

For many years this station and Kirkby personality Bill Brownhill were almost inseparable. One-armed Bill spent much of his life as a booking clerk at Kirkby Central, but it is as a gardener that he is mainly remembered. Largely through his industry and expertise the tiny station was once a place of delight, colourful in both summer and winter, deservedly winning prizes in the best-kept station competitions run by the LNER and BR. The train shown below is a railway enthusiasts' excursion to Swindon.

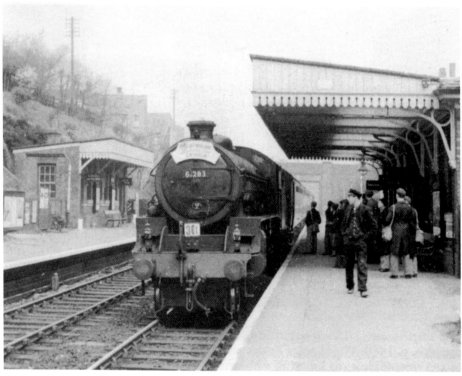

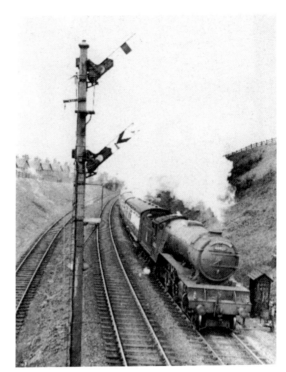

The London to Sheffield route of the old Great Central Railway had two 'named' trains daily – the *Master Cutler* and the *South Yorkshireman*. The 'Yorko' is shown heading south near Kirkby Bentinck station.

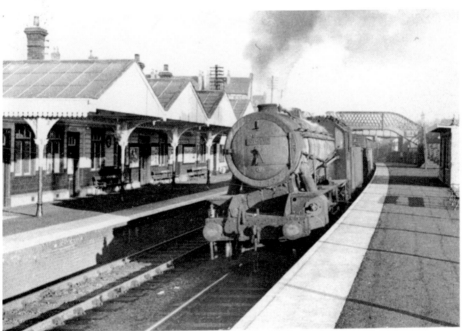

An excellent view of Kirkby Bentinck station in 1952. Sir John Betjeman wrote in his poem 'Great Central Railway: Sheffield Victoria to Banbury': 'Dark red at Kirkby Bentinck stood a steeply-gabled farm ...', and then went on to mention Kirkby, proving that he must have visited the old part of the town.

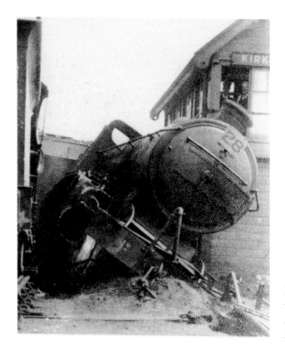

In May 1929 this LNER locomotive, working coaching stock, and travelling at 45 mph, hit a train of empty wagons and was derailed near Kirkby Bentinck.

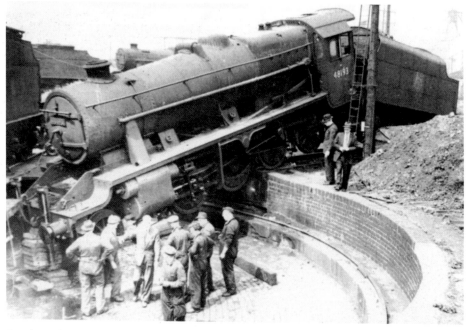

Another calamity, this time at Kirkby locomotive sheds in 1959. This 8F locomotive, no. 48193, had been coaled, watered and oiled up ready for duty and was parked on the short dead-end behind the turntable. Unfortunately the tender brake had not been screwed down and when another locomotive used the turntable the vibration started 48193 rolling. Unbelievable as it may seem, by the end of the day breakdown gang experts had the engine back on the rails and ready for work.

A group of schoolboys visiting the
Mansfield and Pinxton Railway crossing
house which once stood near the Kings
cinema on Urban Road, *c.* 1945.

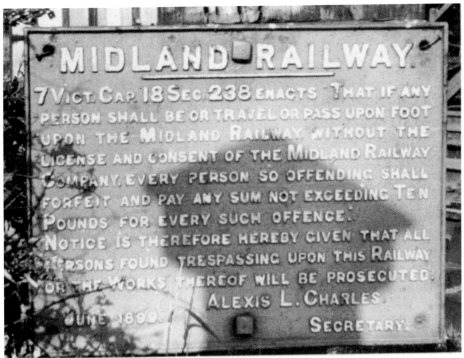

In June 1899 the Midland Railway erected warning signs for would-be trespassers at the level
crossing near Bentinck Colliery Sidings signal box. At that time a fine of £10 was a considerable
amount of money.

A Bank Holiday excursion heads for the Derbyshire Dales. The old station house is on the left, and beyond, gasholders in the Council Yard. On the right are the old station buildings.

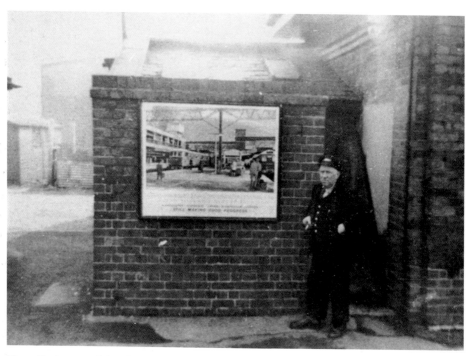

Harry Butler served for many years as a porter at the Midland station. He was also crucifer at St Wilfrid's Church.

Lindleys Lane bridge over the Midland line frames a Saturday afternoon football excursion to Derby. The bridge has been demolished.

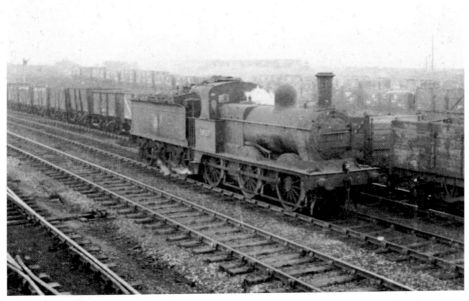

This Midland Railway locomotive was well over sixty years old when photographed going on shed after a spell of banking duty. The footplatemen did their best to break this antique machine to try and rid themselves of it, but never quite managed it. The Midland built its locomotives – and everything else – to last!

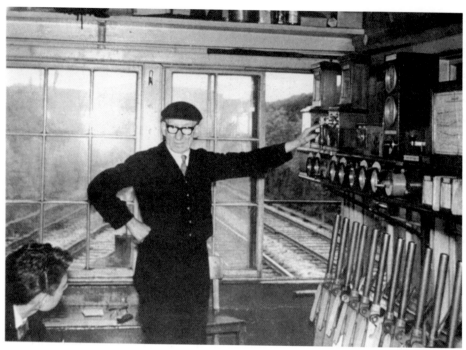

Long-serving signalman Mr Eldred at work in Kirkby South Junction box, 1950. In the background is the bridge which carried Lindleys Lane over the three LNER routes.

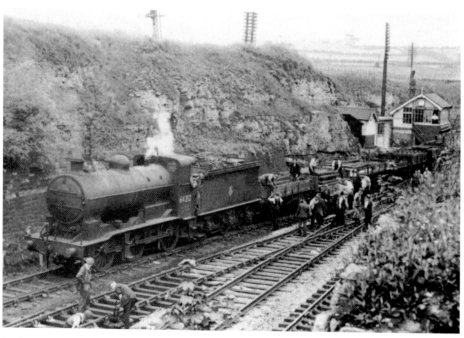

Railway engineers carrying out track maintenance and re-laying on a Sunday afternoon. The railways hereabouts were too busy to permit this kind of work during the week.

Driver Bill Billingham and his fireman watch the photographer as their locomotive pulls up the steepest part of the incline. The path on the left leads up to an area of uneven ground known as the 'Humps and Hollows' and down to Kirkby Quarries.

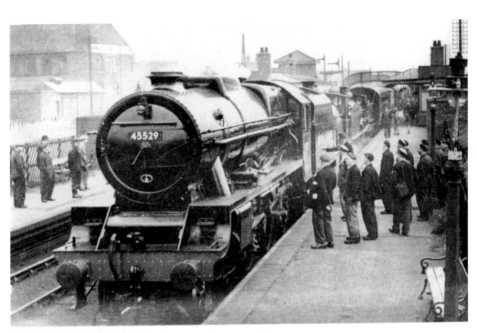

Patriot class locomotive no. 45529 was in Kirkby Midland station to mark a very special occasion – the centenary of the death of George Stephenson, who lived at Tapton House, Chesterfield. The locomotives behind were all preserved machines and were exhibited at Chesterfield Market Place station. During the exhibition no. 45529 was given the name *Stephenson*.

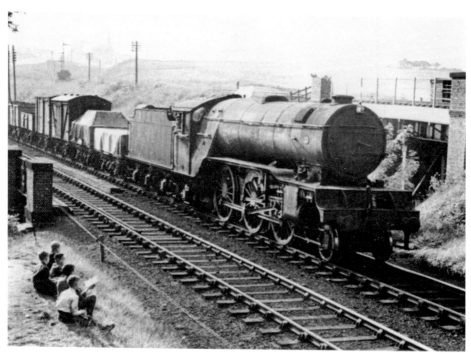

Five young enthusiasts give the V2 class locomotive and its train their full attention. They have chosen an excellent viewing place alongside the old Great Central line in Portland Park.

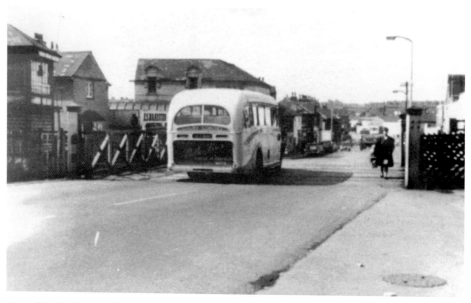

One of Butler Brothers' buses goes over the level crossing in 1965. Those crossing gates must have contributed significantly to road users' blood-pressure over the years. When they were closed against the road, traffic often queued in one direction as far as the Kings cinema and in the other almost to the Four Lane Ends.

five

At Your Service

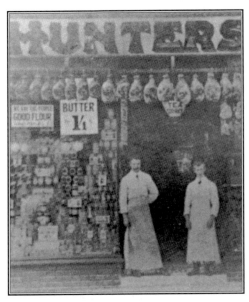

Hunters, provision merchants, c. 1910.

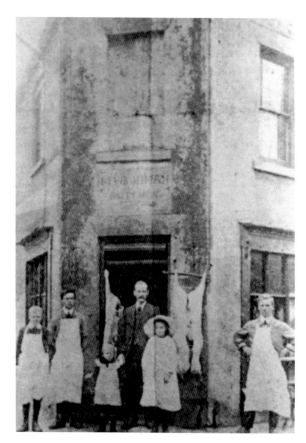

Mr Wightman in the early days of the family butchery business. The business is run today by the grandson of Tom Wightman (Tom is the young man on the right) in a shop only yards away from the premises shown. The original corner site became part of the Regent cinema entrance.

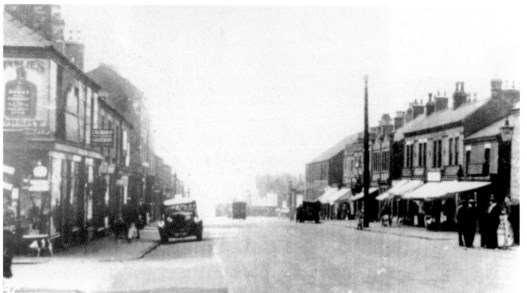

Station Street, looking towards the Midland Station, c. 1935. At the time this thoroughfare was considered to be one of the best stocked shopping streets in the district.

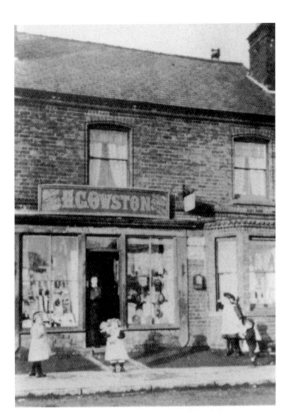

Owston's, Annesley Woodhouse. This drapery and haberdashery shop was also the post office. Mrs Owston was the shopkeeper and her husband the postmaster; he was also one of the first professional photographers in the district.

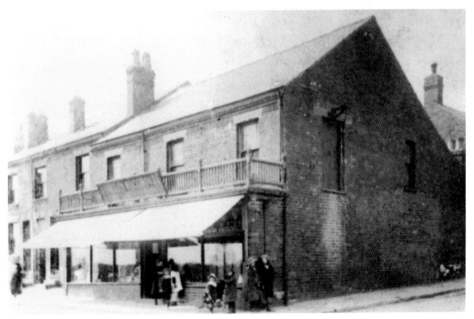

No. 1 Branch of the Kirkby-in-Ashfield Industrial Co-operative Society was opened on 15 October 1892 at the corner of Sherwood Street and Forest Road, Annesley Woodhouse. It was later taken over by the Langley Mill Co-operative Society before ultimately passing into private ownership.

Smith's newsagents, Victoria Road.
Placards advertise long-gone newspapers
– *Daily Herald, Nottingham Journal,
Post Issue* (essential reading for racing
enthusiasts) – which were all going
strong in the 1930s. The newsagent's,
modernised and under different
ownership, still serves the community.

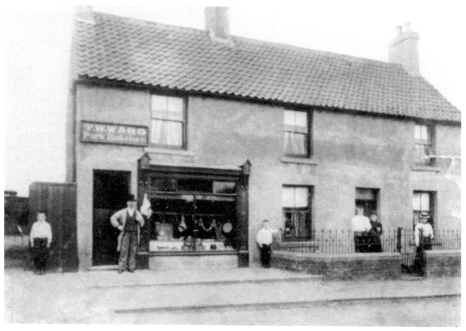

These Victoria Road buildings have housed various businesses over the years, including this butcher's
shop run by Mr T. W. Ward in the early 1900s. The house next door, when it was converted into a
shop, became first a patisserie, then a fish and chip shop, and is now a take-away.

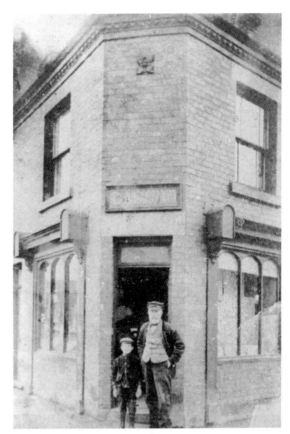

'Unwin – Medical Herbalist' ran the legend on the shop that stood for years on the corner of Morley Street and Station Street. At one time wallpaper was sold there, but subsequently the place was crammed with patent medicines that, for just a few pence, might restore health and vigour. The top photograph shows old Mr Unwin and one of his sons, and below is George Unwin, who later ran the business.

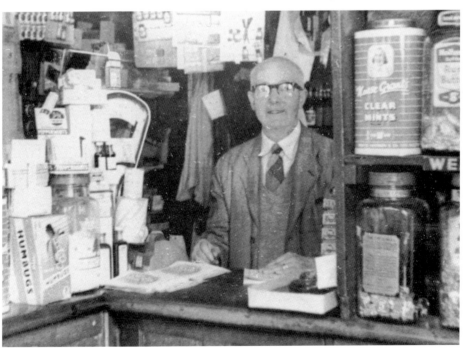

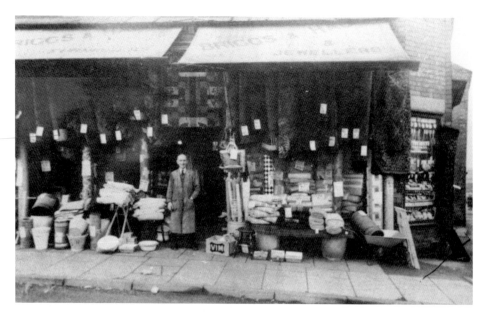

Tom Welch in the doorway of Briggs and Hague, General and Hardware Store, at the corner of Pond Street and Lowmoor Road. Tom first managed this shop and later bought the business, which at one time offered a pawnbroking service, and ran it in partnership with his son, who later transferred to premises in Station Street.

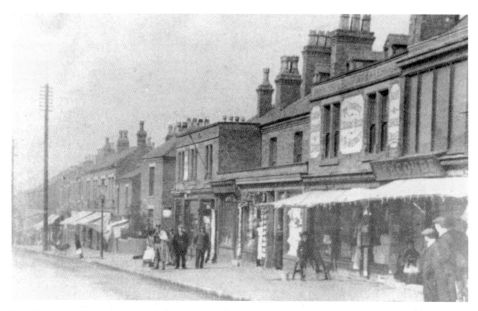

Prominent in this 1916 view of the top end of Station Street is Newcombes, the local emporium. The painted notices above the sun blinds announce it is the 'Oldest Established House in the District'. It sold as comprehensive a variety of household goods as anywhere in the area. The house behind the street lamp was the home of Dr A. B. Waller, a much respected local physician.

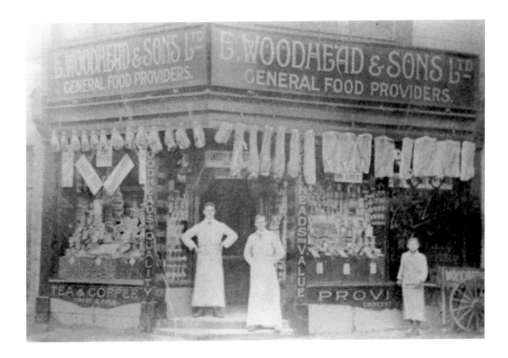

Two well-remembered provision establishments ready for the Christmas trade. E. Woodhead and Sons had their premises on the corner of Byron Street and Lowmoor Road; the India and China Tea Company stood opposite only a few yards away. Food was relatively cheap then and trading hours were long. It was not unusual for shops to be open until 8 p.m. or even later at weekends to compete with stallholders in the old Market Hall.

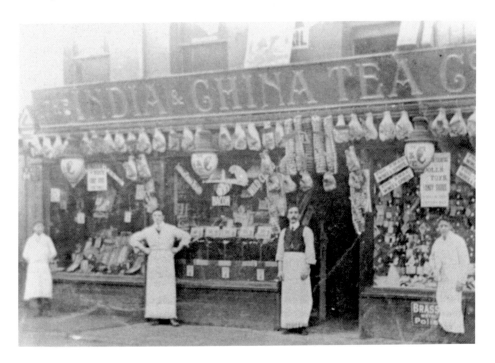

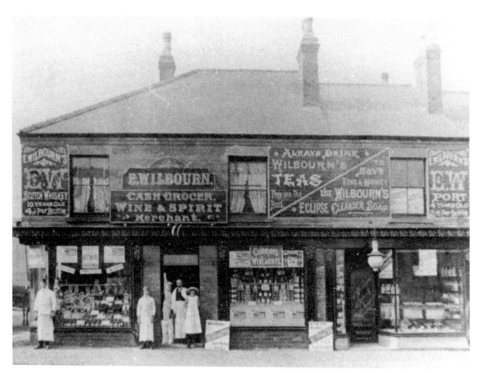

Wilbourn's, grocers and specialist vintners, 1912. This business celebrated its centenary in 1989.

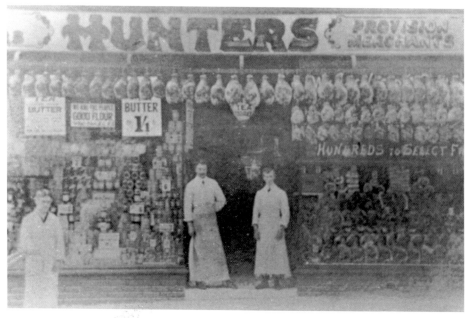

Hunter's, seen here in around 1910, was yet another flourishing provisions store in the centre of Kirkby. Its customers must have been especially fond of hams, for not only are there dozens on display, but a sign proclaims 'hundreds to select from'. Butter is priced at 1s 1d per pound.

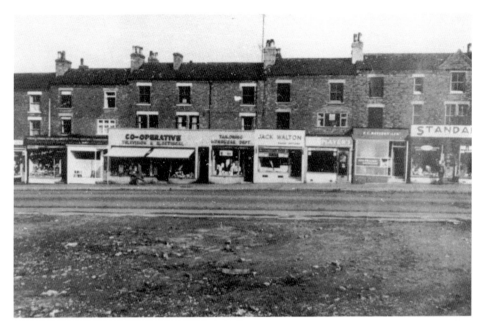

Some years after the Second World War the cottages that stood for many years on the south side of Station Street were demolished. The shops in the photograph were at the time occupied by Mansfield and Sutton Co-op; butcher Jack Walton; F. C. Davison Ltd, opticians; and the Standard Gramophone Company.

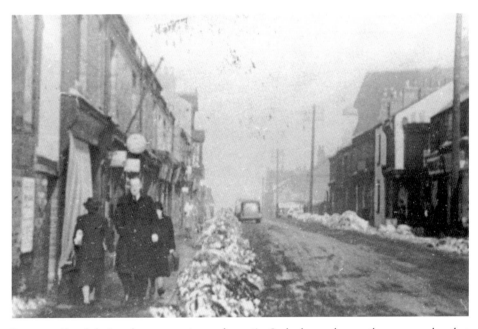

Lowmoor Road during the severe winter of 1946/7. So bad was the weather on one day that trains on the Central and Midland lines from Nottingham to Mansfield couldn't proceed further than Annesley and Kirkby tunnels.

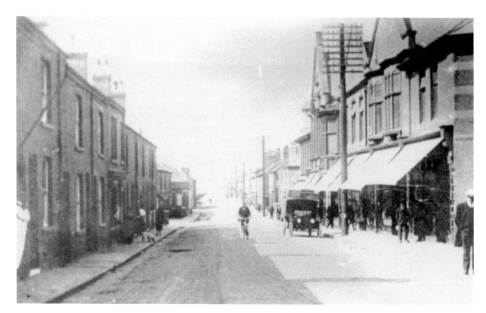

Lowmoor Road, photographed at a time when walking was the main form of locomotion. If you did travel on wheels you would almost certainly have the doubtful comfort of solid tyres! On the right is the line of Co-operative Society shops – greengrocer's, butcher's, furniture and hardware, and general provisions stores.

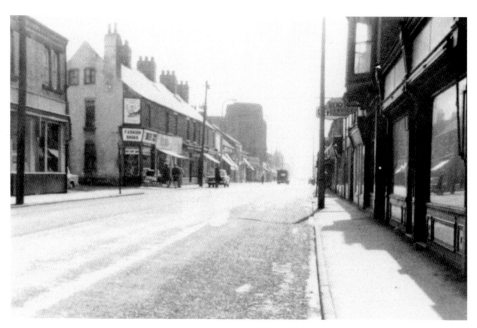

Lowmoor Road looking towards the Four Lane Ends. On the corner of Byron Street, leading off to the left, was Pounders shoe shop; on the immediate right, Cresswells butcher's, and just beyond, Greensmiths, long-established motor engineers.

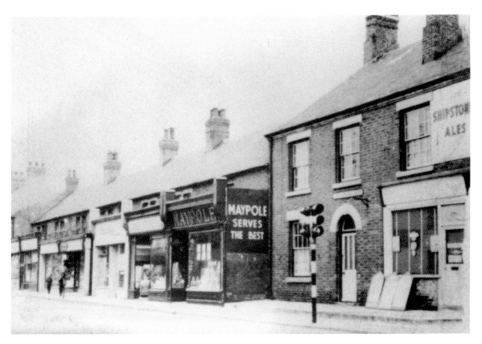

Lowmoor Road in the early morning, before the crowds arrive. The buildings are still there but all the businesses have changed hands. Kirkby's older residents will no doubt remember Mr Lee, the Maypole's manager, and the way he dextrously patted butter into shape with two small wooden bats.

Kingsway photographed in the 1970s, showing how much it has changed. A number of the shops on the right were demolished to make way for redevelopment. The Star cinema, long gone, was once prominent, its entrance on the pavement just beyond the line of shops.

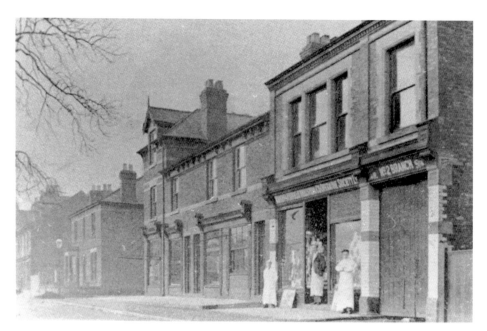

Co-op shops at the top of Victoria Road, before 1914. At this time the shops comprised No. 2 Branch of the Kirkby-in-Ashfield Industrial Co-operative Society. Later they became No. 41 Branch of Mansfield and Sutton CWS. The buildings remain, completely modernised and long since taken over by other businesses. The house on the far corner of Park Street was for many years the home of Dr F. G. Stuart.

Hodgkinson Road looking towards Station Street. The shop and houses on the left were demolished as part of the scheme to enlarge the Festival Hall and create an extensive car park for its patrons.

six

At School, At Work, At Play

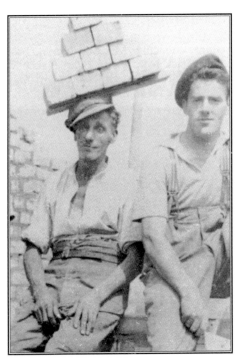

Workmen photographed during the building of houses on Rowan Drive, 1952.

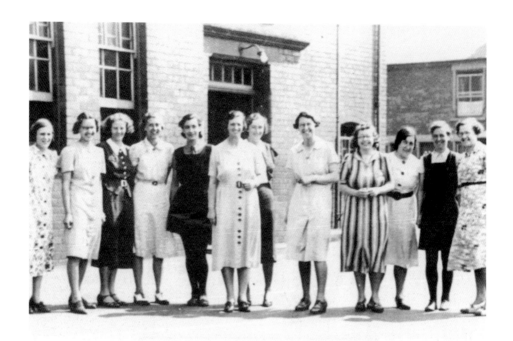

Jeffries Senior Girls' School staff, 1941. Mrs M. Coleman, the headmistress, is sixth from the left. The school, formerly Vernon Road Senior Girls' School, had recently been renamed after local and county councillor Mrs Ada Jeffries. Below, the members of the school's shinty team of 1935; back row, left to right: Nancy White, Iris Flint, Norah Smith, Dorothy Drabble, Daisy Turner; seated: Jessie Staley, Anise Collins, Edna Booth, Pearl Sargent; front row: Sylvia Needham, Lily Mattley.

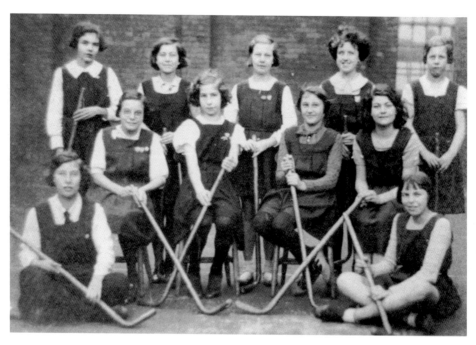

Church Street Infants' School, *c.* 1960. The school is remembered with affection by many Kirkby people, but even today the name of headmistress Miss Quinion evokes memories of her strict discipline. The school is now the business premises of Mr Owen Parkin.

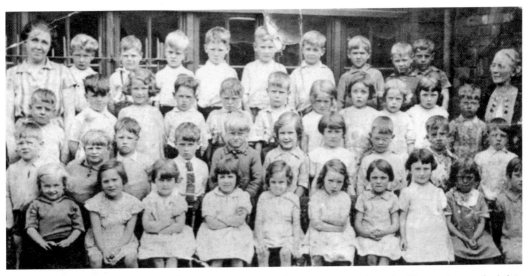

A class of the Church Street school, early 1930s. Miss Quinion is on the right. The teacher on the left is Miss Kate Sharman, whose nephew was Harold Larwood, the famous Nottinghamshire cricketer.

Diamond Avenue School, built more than a hundred years ago, but no longer in use. One of its earliest headmasters was Mr Thomas Pickard, who lived in the commodious School House next door.

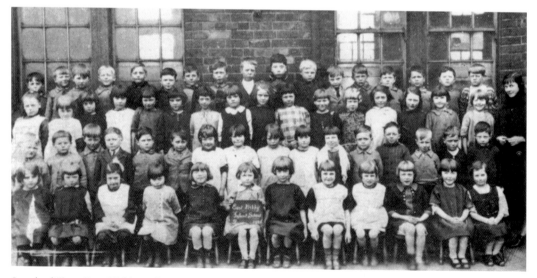

Standard Two, East Kirkby Infants, 1926. Miss Kerr is the teacher. Some of the children seem rather suspicious of the camera.

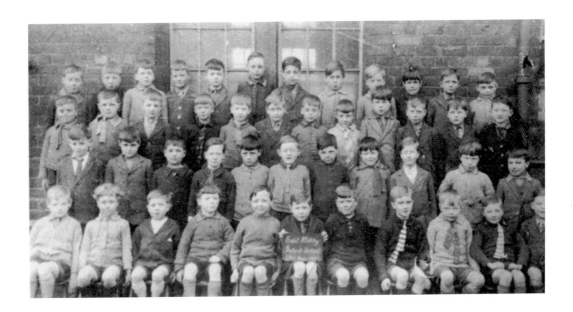

Belonging to East Kirkby Infants School in 1925 was evidently a serious business. But there are a few smiles among the scholars of Annesley Council School in 1932, as the photograph below shows. The tall girl in the second row from the back was later a Kirkby Carnival Queen.

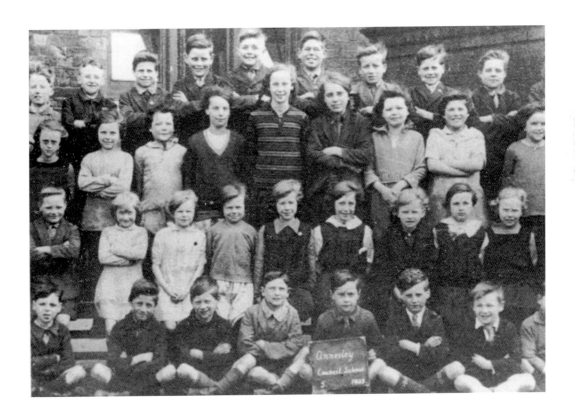

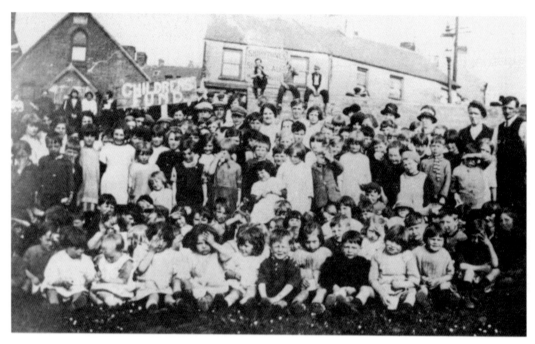

Beneficiaries of the Children's Fund during the hard days of the 1920s. The children and helpers were photographed during the summer holidays outside the Church of Christ at the bottom of the Shoulder of Mutton Hill.

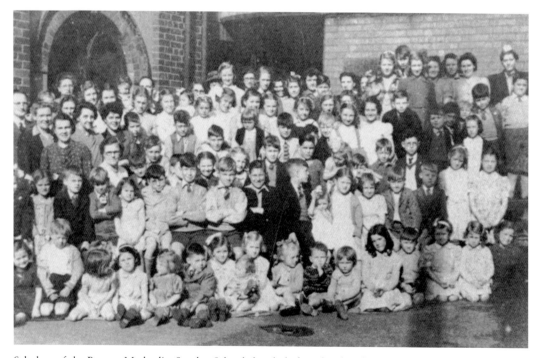

Scholars of the Bourne Methodist Sunday School shortly before the church was closed.

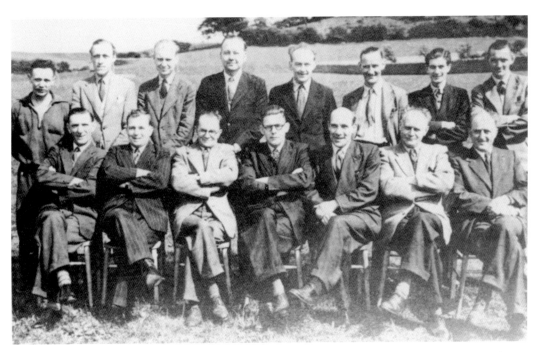

Kingsway Senior Boys' School staff, *c.* 1950. Standing, left to right: Messrs Roberts, Wells, Williams, Nickerson, Shacklock, White, Hodges, Stirland; seated: Messrs Mills, Baker, Allin, Cox (headmaster), Abbott, Reeve, Howlett.

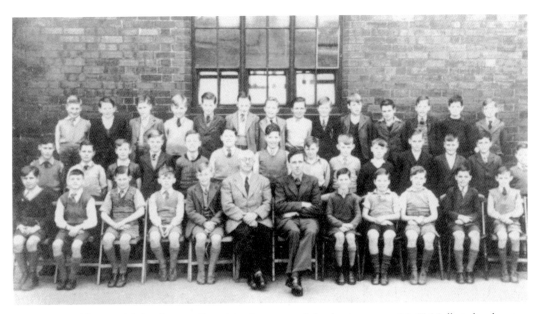

East Kirkby Boys' School 1947. Seated in the centre of the front row are Mr T. Mollart, headmaster, and on his left class teacher Mr Skermer.

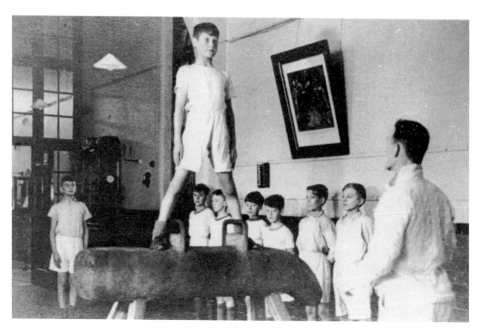

Gymnasts at Kingsway School in the 1930s. Under the watchful eye of Alan Noon, himself a notable performer and all-round sportsman, Leslie Shaw awaits the word of command. The next to go is Dick Draper, while waiting at the side are P. Gowan, Ron Sparkes, Harry Tow, Stan Murray, Norman Scothern and Malcolm Rose.

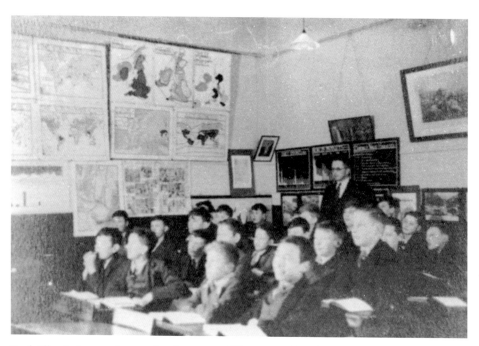

Fred Allcock, later to become headmaster at Ollerton, teaching his class at Kingsway. The year is probably 1935.

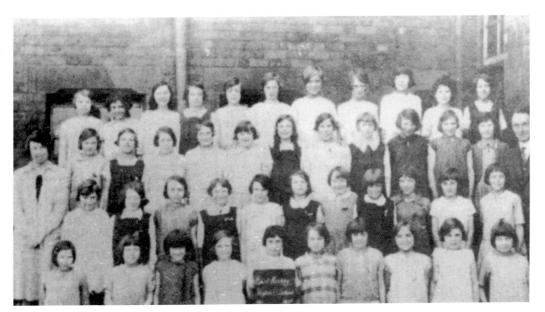

East Kirkby Higher School pupils, 1939. This school later became Kingsway Junior. The teacher on the left is Miss Turner; headmaster Mr Garnett is on the right.

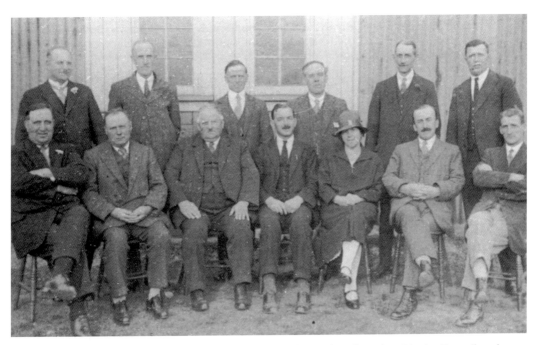

Kirkby's Labour Party representatives, 1920s. They all served on the Urban District Council, and some were also county councillors and school governors. Standing, left to right: F. Berry, R. Smith, W. Ward, W. Bates, P. S. Sargent, J. Carlin; seated: J. Portas, J. Marshall, W. Mattley, W. Bayliss, Mrs A. Jeffries, W. Able, A. Green.

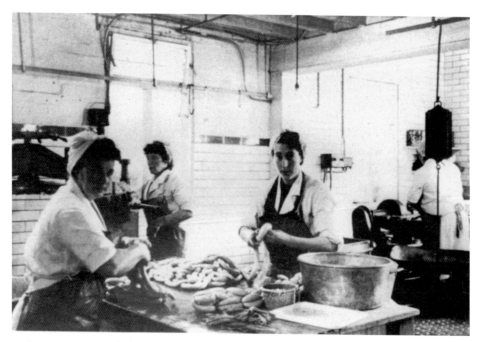

Making sausages at the factory of E. A. Bird & Sons. This long-established firm has a fine reputation for its hams and pork pies.

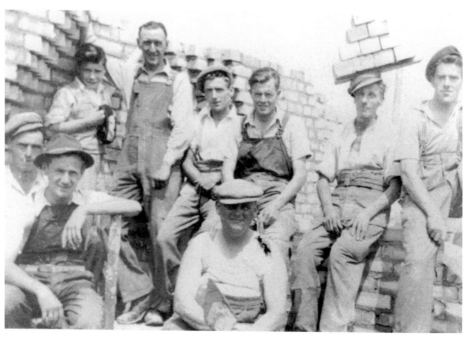

Workmen employed by W. J. Bains and Son, photographed during the building of houses on Rowan Drive, 1952. No one can doubt the expertise of the gentleman second from right nonchalantly balancing ten bricks on his head.

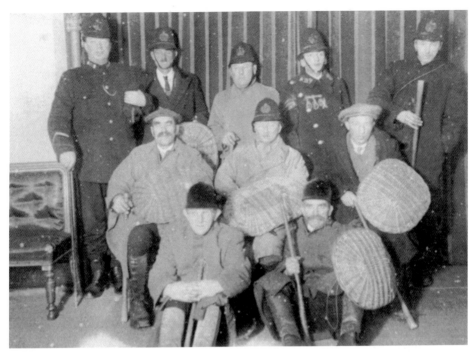

Trespassers beware! Colonel Musters (centre, middle row), Squire of Annesley Hall, with a team of friends and staff, just before setting off around his estate in search of poachers. Despite the attire, the only real policeman is the one on the left. The year is 1910.

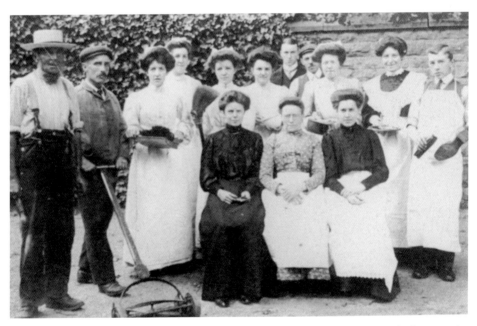

Staff at Annesley Hall, with the tools of their trade, 1920. Note the lawnmower. The lawns at the Hall were extensive, so mowing must have been a time-consuming task.

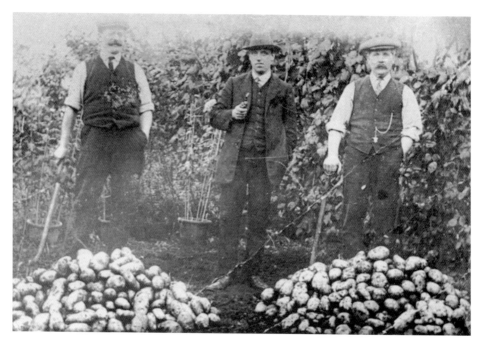

Digging for victory during the First World War. C. Larwood (left) and J. Wightman (right), winners of the Annesley Woodhouse Gardeners' Association potato-growing competition, with some of their produce.

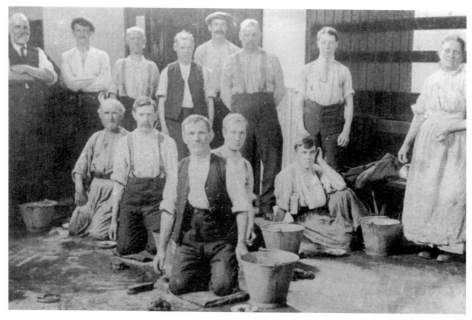

Men of the Wesleyan Methodist Chapel, Annesley Woodhouse, scrubbing the schoolroom floor after the 1915 Chapel Anniversary celebrations. Mrs Albone, wife of the caretaker, is on the right.

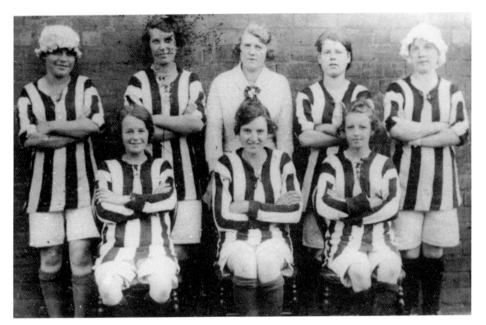

Mayfield Ladies' Football team, 1926. Ready to take on all comers are Gladys Sharley, Grace Smith, Ida Clarke, Ethel Bonsall, Liz Wall, Ira Bramley, Ethel Wharmby and Fanny Lilley.

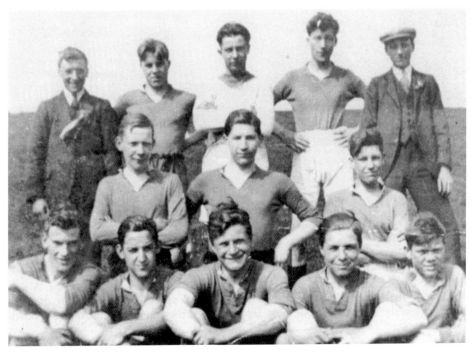

An Annesley Woodhouse men's team of the same year. These lads obviously took their sport seriously.

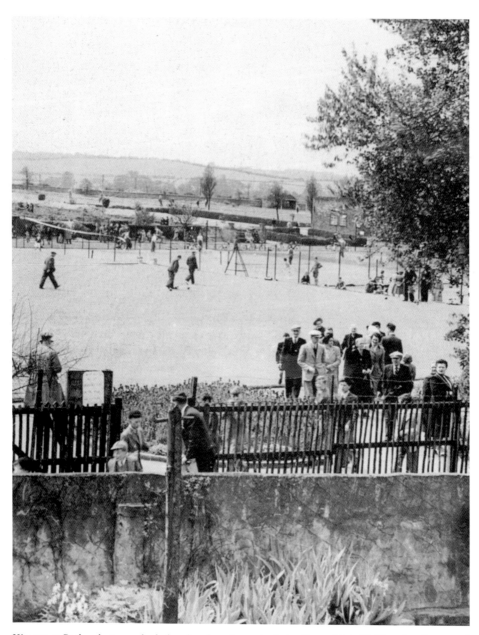

Kingsway Park, photographed shortly after the end of the Second World War. A sober-suited party makes for the exit on what seems to be a special day, judging by the people about. It's hardly Wimbledon, but there are players on the courts, and the men are bowling in earnest.

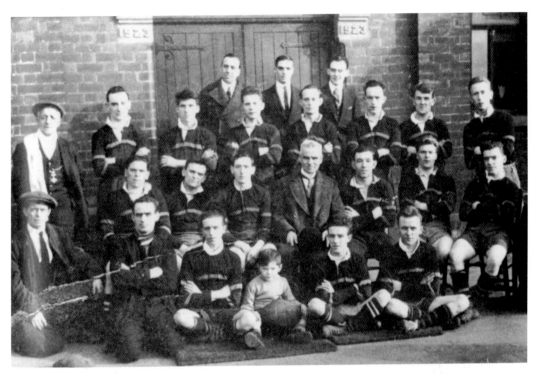

Kirkby Colliery Rugby Club, 1925/6. When a contingent of Welsh miners settled in Kirkby they soon formed a rugby club. Their ground was near what was then Speed's Farm, just off Southwell Lane.

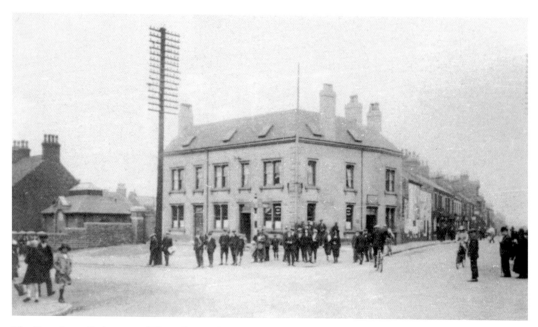

The Four Lane Ends, 1928. When the working day was over this seemed to be the accepted meeting place before deciding how to spend the evenings.

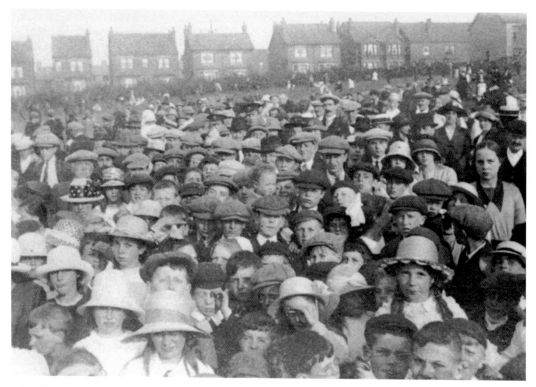

A Bank Holiday gathering, Morven Park, 1928. The sun is obviously shining, but most of the crowd are wearing hats or caps nonetheless.

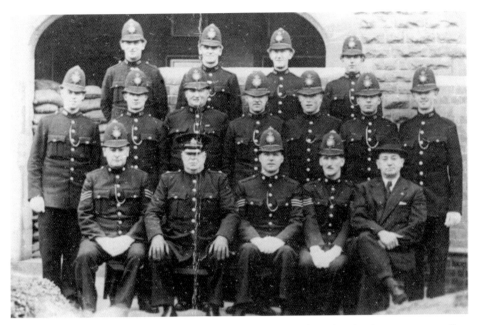

Kirkby Police during the Second World War. The sandbags in the Police Station entrance confirm this was a wartime photograph. Inspector Oscroft, seated second from the left, is shown with his team of regular officers and specials. The gentleman sitting on the extreme right is Mr Hedley Wright, Chief Special Constable.

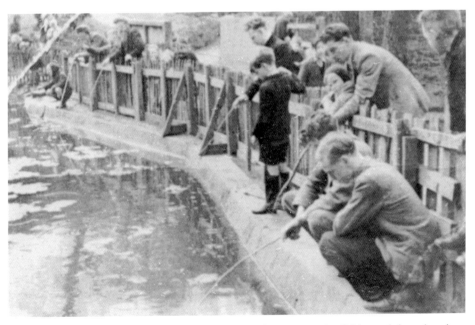

Tiddlers and tranquillity in Portland Park. There may be no expensive fishing rods here, but there is intense concentration as the anglers wait patiently for a bite. But where are the jamjars that were always kept handy to take catches home?

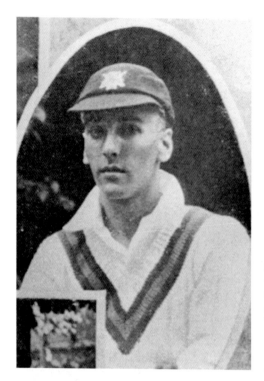

Joe Hardstaff, shortly after receiving his county cap. Hardly ever to be seen in a cap again, this most elegant of batsmen enjoyed an illustrious career for both Nottinghamshire and England. He figured in a stand of 215 with Len Hutton at the Oval in 1938, when the Yorkshireman made his record-breaking 364.

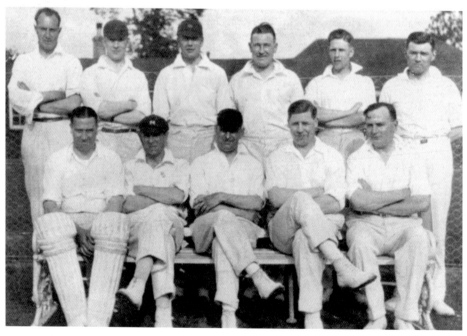

An Annesley Woodhouse cricket team ready to take the field. Kirkby and district was an enthusiastic sporting area, with dozens of football and cricket teams before the outbreak of the Second World War.

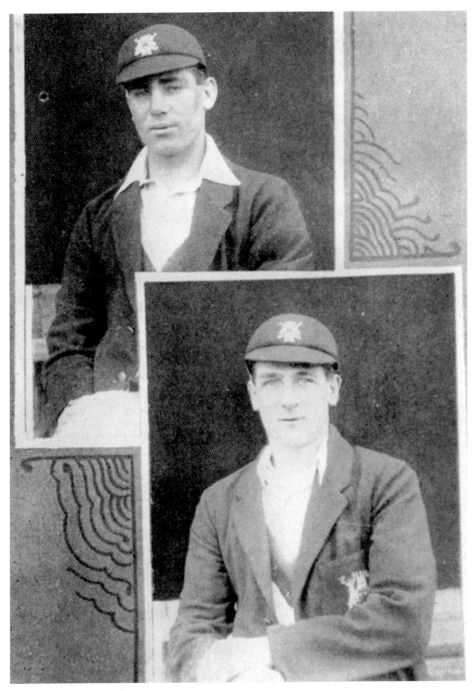

Bill Voce and Harold Larwood. Born locally, they were two of the most feared fast bowlers of their day. They opened the bowling for Nottinghamshire and England will forever be associated with the famous 'bodyline' tour of Australia in 1932/3.

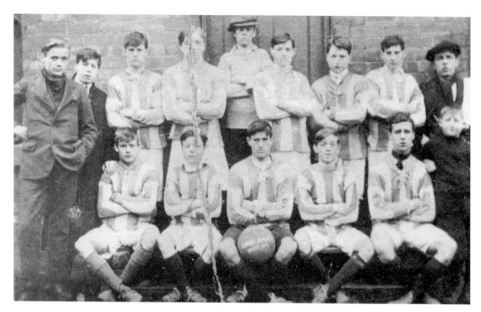

Kirkby Rovers FC, 1930s. Typical of the period, the goalkeeper is wearing his regulation cap while the trainer has his towel ready for any emergencies.

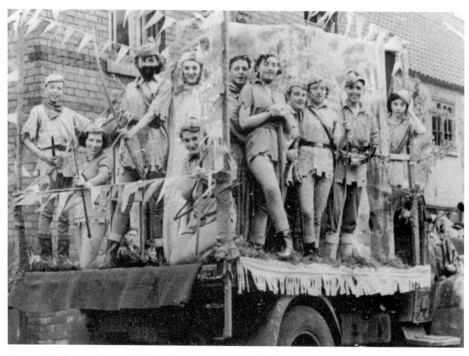

A carnival float at Annesley Woodhouse, *c.* 1935. What better theme in Sherwood country than Robin Hood and his Merry Men?

seven

Walking at Whitsuntide

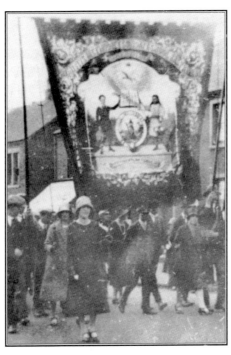

*The Trinity banner held proudly aloft during a
Whitsuntide procession.*

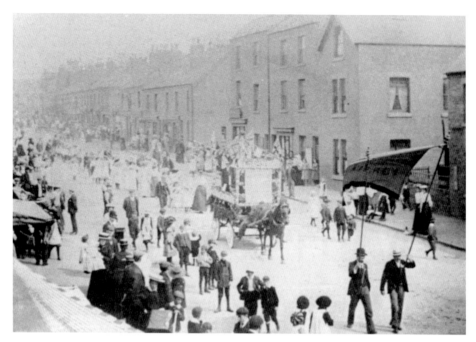

The banner holders, followed by the Temperance Float, lead the Whitsun procession down Station Street, 1910. Not much lightweight clothing is apparent in this photograph – almost all the lads are wearing knickerbockers.

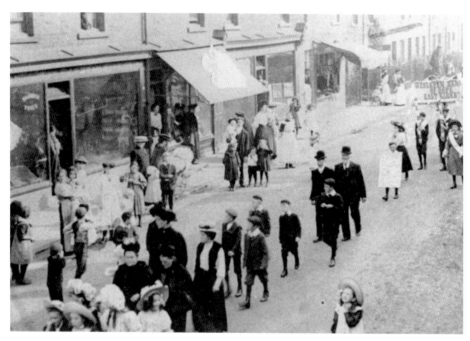

Lowmoor Road, early 1900s. The procession still has some way to go before they get the tea that was their reward for tramping the often dusty streets.

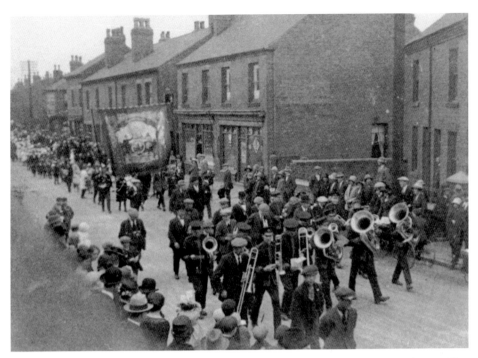

Kirkby and district was well known for its brass bands. Never were they heard to better effect than when leading the Whit Walks.

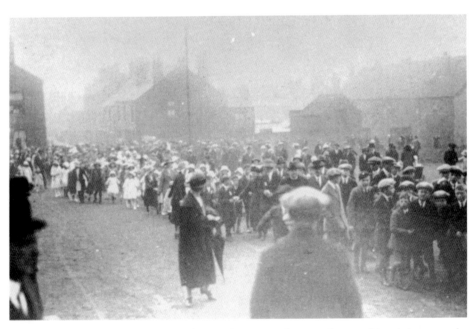

After the procession. Scholars and teachers in this 1920s photograph are making their way to the recreation ground off School Street for the hymn-singing, to be joined there by many adults from the crowd that had lined the route.

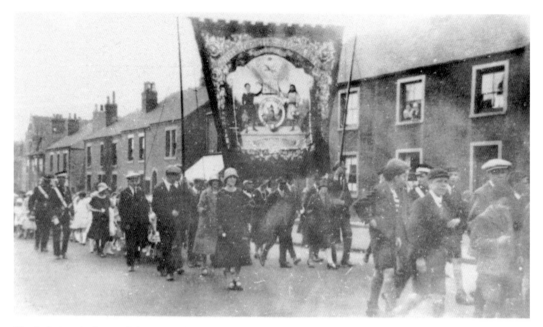

The lady just in front of the Trinity banner is Edith Searson, who wrote entertaining reminiscences of her childhood under the title *I Remember*. She and her husband Ben were staunch Methodists.

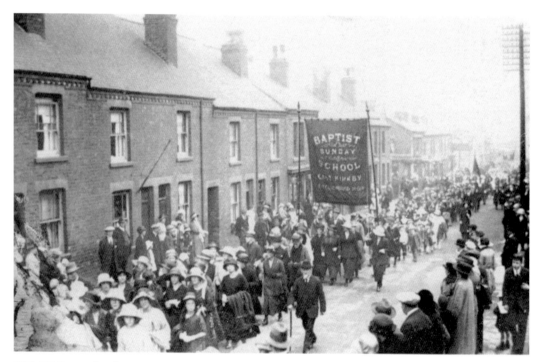

Whit Walks used to be major events in the Kirkby calendar. This photograph, showing the Baptist Sunday School banner, gives some idea of just how well the Walks were supported between the wars.

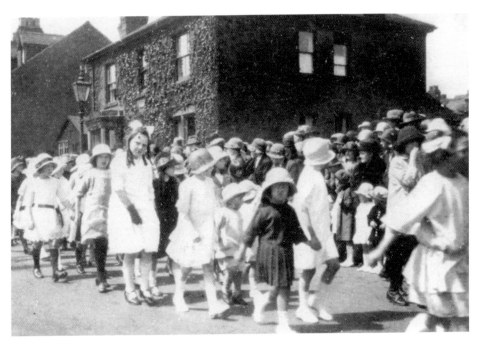

Part of the Old Kirkby Walk, 1928. At the Park Street corner stands Dr Stuart's house, and beside it can be seen the wooden waiting room and surgery.

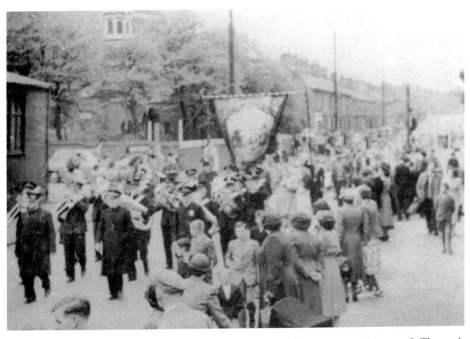

The Salvation Army Band leads the East Kirkby procession along Kingsway, just past St Thomas's Church. The corner of the building on the immediate left was part of the old church hall, which was later demolished. The Kirkby Pentecostal Church now stands on the site.

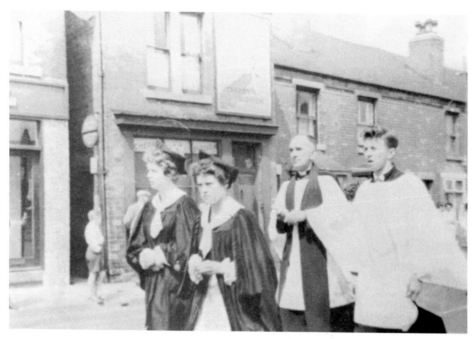

Whitsuntide processions gradually began to lose the support they had once known, but there were still sizeable turn-outs in the 1960s. Here the Revd Sydney Butler, Vicar of St Thomas's, strides out with three of his choristers.

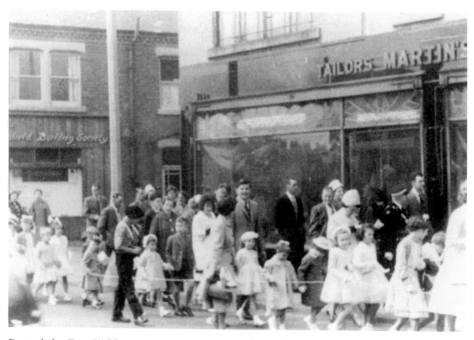

Part of the East Kirkby procession passing the shop of Len Martin, tailor and outfitter, on Kingsway, 1961.

eight

Gone For Ever

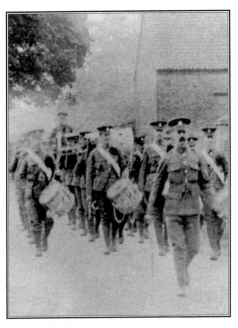

A First World War recruiting sergeant leads his band through The Park.

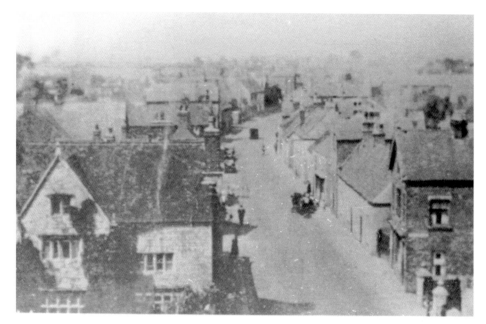

Church Street, photographed from high up in the spire of St Wilfrid's, 1920. In the left foreground is the Manor House. The house opposite was once a shop. Yards – almost miniature streets – led off both sides of the road, and on a wall near the Duke of Wellington, one of the few buildings remaining, a large metal disc stated it was 120 miles to London.

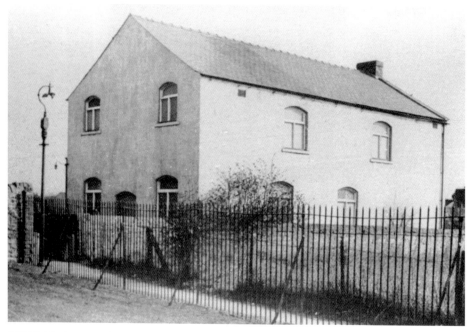

Old Kirkby Baptist Chapel, in which generations of well-known families worshipped. Eventually the building was pulled down and Old Chapel Close was built on the site.

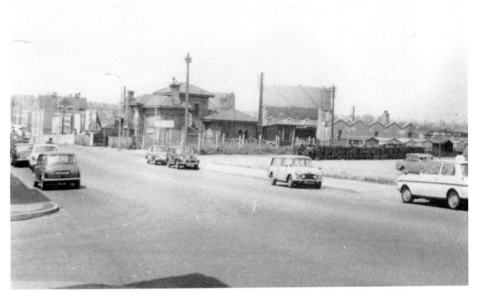

The hoardings fronting Urban Road, the Midland Railway booking office beside the level-crossing, and the two gasholders in the old Council Yard were all once well-known Kirkby landmarks.

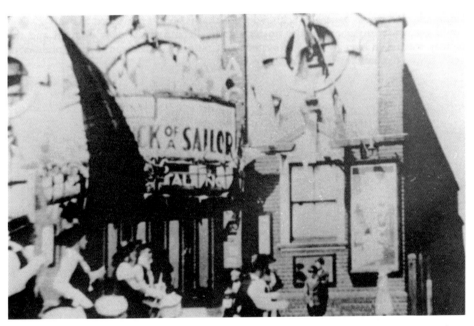

The Kings, one of Kirkby's three cinemas. This cinema opened on Whit Monday 1912. Apart from a period when the silent films gave way to the 'talkies' and the place was refurbished, it remained in business until July 1961. *Luck of a Sailor* was the film showing when this photograph was taken. Here the Kirkby Arcadians Carnival Band is about to pass on one of its parades.

The hosiery factory of William Walker & Sons. For many years this was a Kirkby landmark, and it was generally acknowledged that if you were trained at Walker's you could get a job anywhere in the hosiery trade. Eventually Walker's closed and the factory was taken over by the Kirkby Seating Company, which ran it for a number of years before the building was demolished.

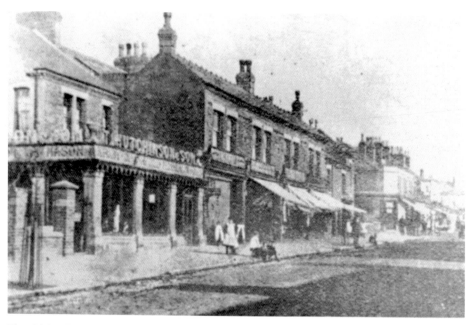

Flourishing Station Street shops, early 1900s. The pillared building on the immediate left was a sort of 'tombstone garden' advertising the business of Hutchinson & Son, ornamental masons.

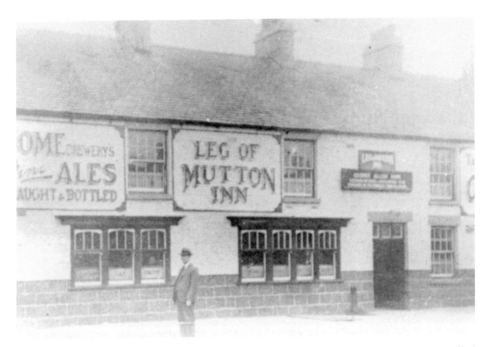

Licensee Mr Allen Kirk standing outside the Leg of Mutton Inn. This old public house was pulled down when the Byron Street area was incorporated into the Kirkby centre development. 'The Leg', as it is affectionately known, moved to a new site in the Precinct.

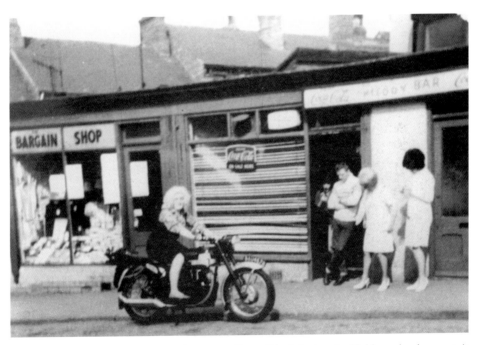

The Melody Bar on Lowmoor Road, c. 1960. Demolished during the Kirkby redevelopment, it used to be a popular meeting place for the younger element.

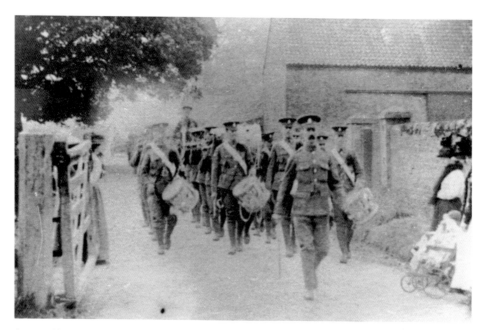

A recruiting sergeant leads a band through Annesley Park during the First World War. The Park, gated then, saw little road traffic. The farm buildings seen on the right have now been demolished, and the road through the Park, with the M1 less than a mile away, now takes a constant stream of traffic.

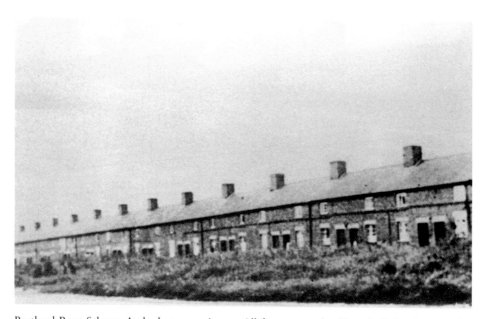

Portland Row, Selston. And what a row it was. All forty-seven dwellings, built by the Butterley Company in 1823, were joined together. Anyone wanting to deliver to the rear of the houses had to go right to the end of the row to find a communal access. Comparatively recently pulled down, the row was surely a unique example of colliery housing.

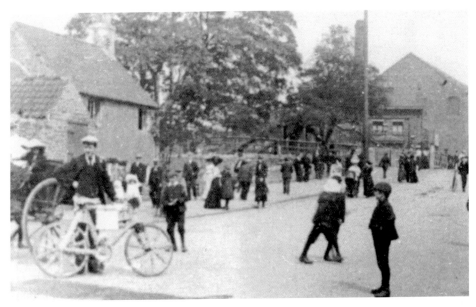

This photograph, taken more than a hundred years ago, shows the Midland station-master's house, later the booking office, on the left just beyond the level-crossing. Behind it is the Walker factory. The house in the foreground was demolished when the council offices were built in 1911. The photographer was obviously recording a special day; the solid-tyred bike had been decorated for the occasion.

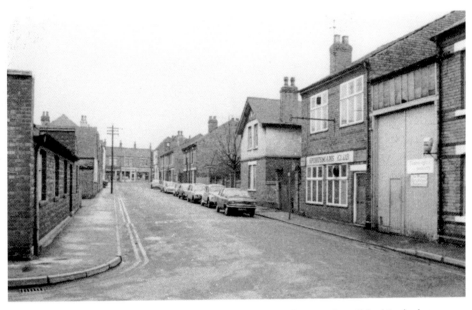

The Sportsmen's Club and Stirland's Garage on the near right were demolished in the late 1970s when the site was being prepared for the Kirkby Centre Comprehensive School. The gabled house just beyond the Club was once the home of Mr and Mrs M. H. Fox, both well-known Kirkby residents.

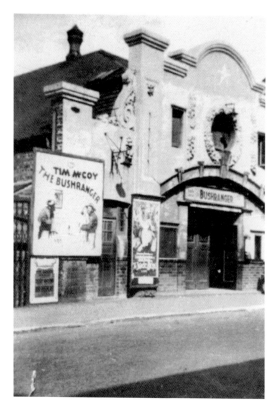

The Star cinema was never short of patrons, and for years was managed by Mr Percy Thorpe. In its heyday, like the King's, it offered the attraction of live speciality acts between the first and second houses.

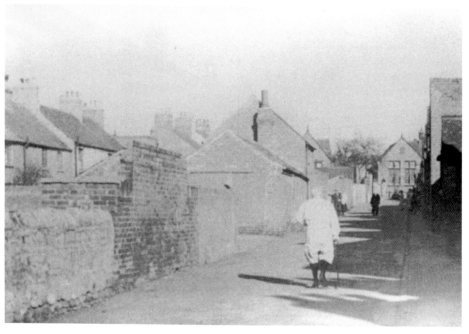

Byron Street shortly before demolition. Notice how narrow the road was between the rows of houses. In the distance can be seen part of Morven Park School.

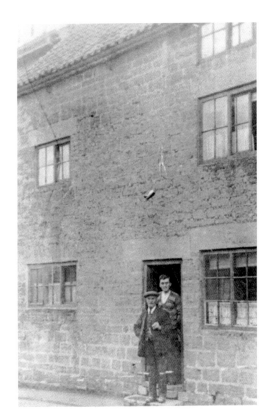

One of a row of stone cottages in Chapel Street, adjacent to the Sherwood House Inn. When the cottages were pulled down the site was eventually made into the inn car park. The old gentleman is Mr Atkinson, with (behind) his son Albert, who served in one of the Scottish regiments during the Second World War.

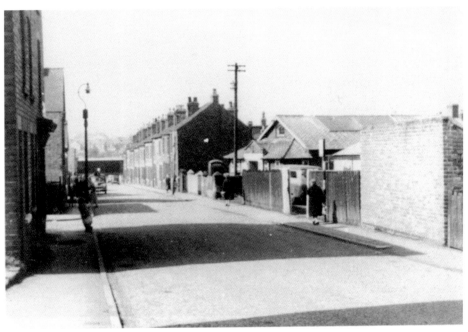

Pond Street. The single-storey building on the right, formerly the Gospel Hall, was once the main post office. Note the old-style telephone kiosk behind the wall.

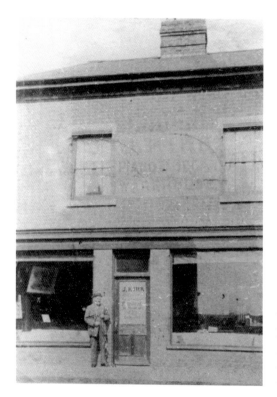

Mr J. Kirk outside his Lowmoor Road premises in the early years of the twentieth century. The double-fronted shop was then a piano and organ warehouse. In keeping with the demands of the day it is now a take-away.

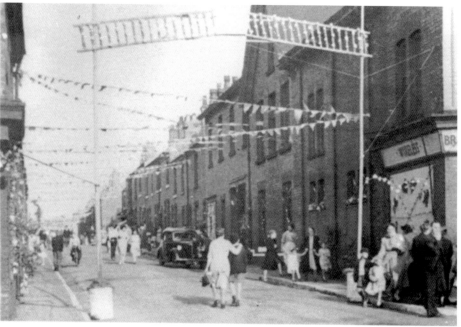

Sherwood Street decorated for the Coronation in 1953. This eagerly awaited occasion gave many of Kirkby's residents the chance to trim up the streets and celebrate. It was an opportunity not to be missed.

nine

A Page or Two of History

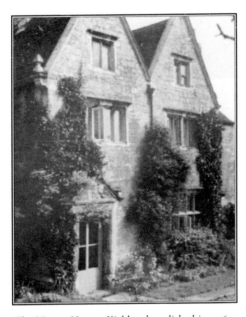

The Manor House, Kirkby, demolished in 1965.

Arthur Martin (left) succeeded his father as licensee of the Nag's Head, known locally as 'The Nag'. For one particular feat of daring he became a local legend in his lifetime. In 1901, when a fair arrived in Kirkby, it was announced that Arthur would enter the lion's cage along with the lion-tamer. Quaking he may have been, but he did as he said, and the watching crowd, many of whom had made bets, sang 'For he's a jolly brave fellow'. It was afterwards remarked by a local wit that the lion must have had a drop of Arthur's best before the landlord entered the cage. The photograph below is the first ever taken of the Nag's Head.

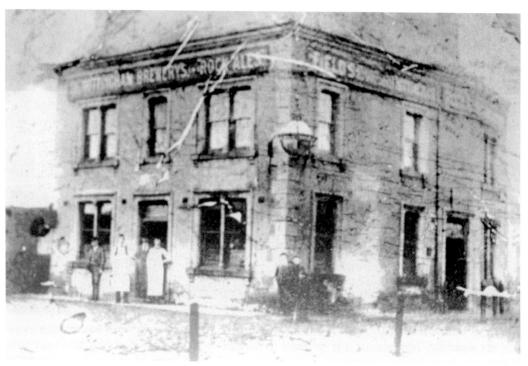

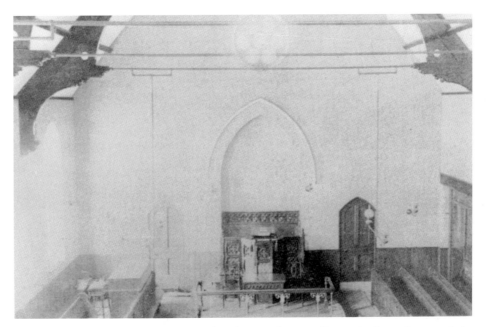

Interior of the Forest Road Methodist Church, Annesley Woodhouse, in the early part of the twentieth century. Since then the church has been modernised and completely refurbished.

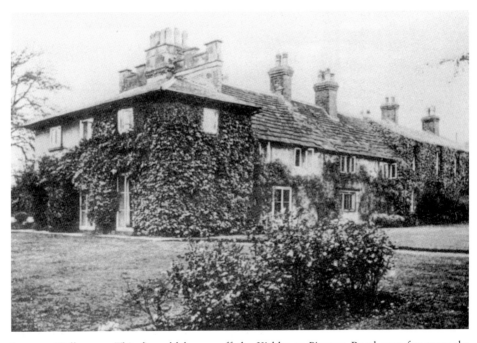

Langton Hall, 1911. This fine old house, off the Kirkby to Pinxton Road, was for years the home of the Salmond family. It was, however, allowed to fall into disrepair and was eventually demolished.

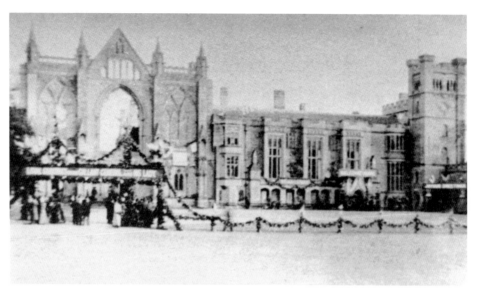

Newstead Abbey, 1856. This was a great occasion – the Abbey having been decorated to welcome home General Gerald Littlehales Goodlake, VC, from the Crimean War.

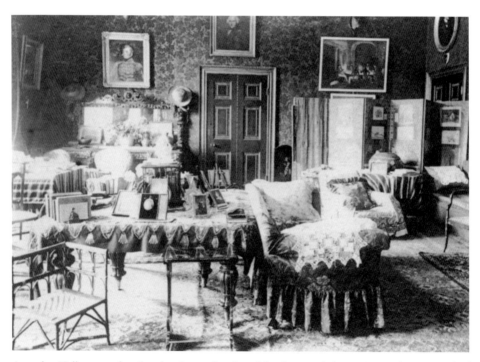

Annesley Hall, 1900, showing the cluttered order of furniture and decoration perhaps typical of the period in the houses of wealthy landowners.

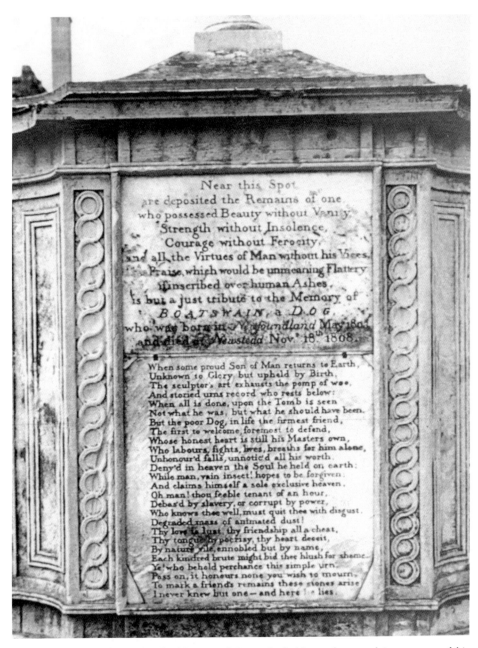

Boatswain's tomb at Newstead Abbey. Lord Byron had this tomb erected in memory of his beloved Newfoundland dog. The inscription reads: 'Near this Spot are deposited the remains of one who possessed Beauty without Vanity, Strength without Insolence, Courage without Ferocity, and all the Virtues of Man without his Vices. This Praise which would be unmeaning Flattery if inscribed over Human Ashes is but a just tribute to the memory of Boatswain, a Dog, who was born in Newfoundland, May 1803, and died at Newstead, November 18th, 1808.'

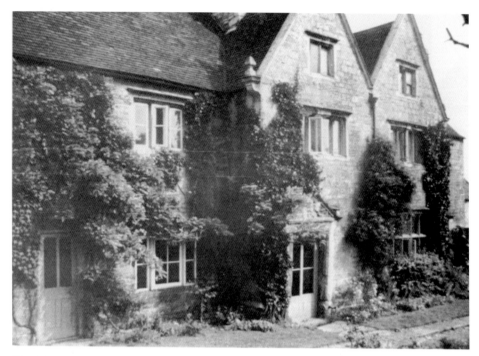

The Manor House was a part of Kirkby for more than three hundred years. It was situated on what is now Manor House Court, directly opposite St Wilfrid's Church. Its demolition in the early 1960s destroyed a precious piece of Kirkby's heritage in what is now, ironically, a conservation area.

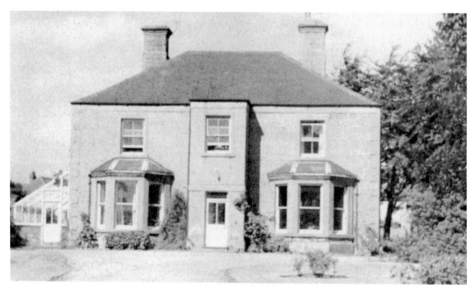

Kirkby House. Now a restaurant and hotel, it was for many years the home of Miss Kate Hodgkinson, once one of the principal landowners of the district. She was a generous benefactress to St Wilfrid's and the reredos in the church was given in her memory in 1928.

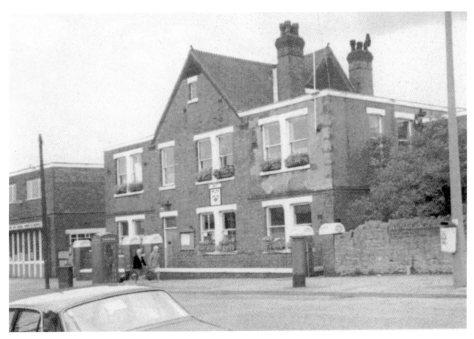

The old council offices on Urban Road were built in 1911 and demolished in 1986. On the left is the Fire Station before the removal of operations to Sutton Road.

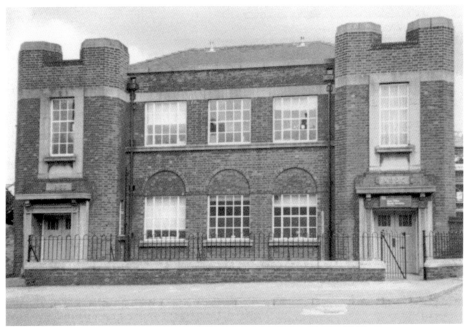

The Child Health Centre, Urban Road. When this building was opened in 1933 it was widely known as 'The Clinic' and catered for the needs of countless Kirkby and district children. The first public library was located in one of its rooms, a few strides away from hundreds of tins of baby food!

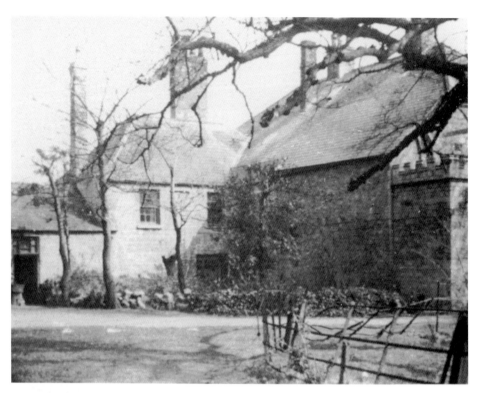

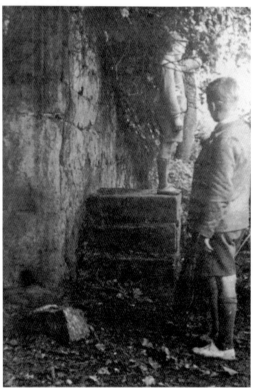

Kirkby Hardwick, *c.* 1940. Since demolished, it provided splendid accommodation for some years after this photograph was taken. A house had stood on the site since the thirteenth century. In November 1530 Cardinal Wolsey, on his ill-fated journey south at the command of King Henry VIII, spent one night there. In the lower photograph two boys from a visiting school party show interest in the mounting block that was no doubt much used in Kirkby Hardwick's prosperous days.

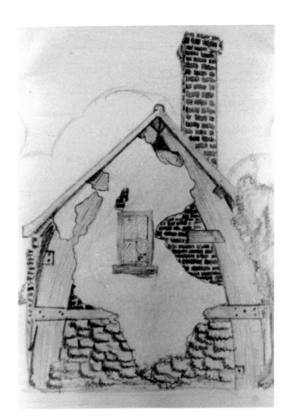

A sketch of the timber-framed Anglo-Saxon house at Kirkby Woodhouse, which was unfortunately demolished in 1937. It is probably from such dwellings that the name Woodhouse derives.

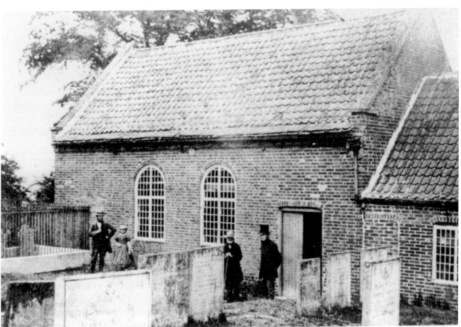

Kirkby Woodhouse Baptist Chapel, c. 1900. The chapel, built in 1745 and carefully looked after over the years, still has a devoted band of members.

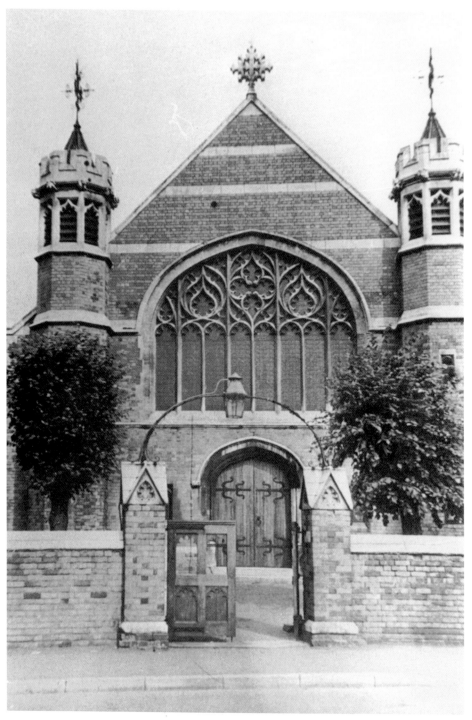

St Thomas's Church. The foundation stone of this splendid building on Kingsway was laid by the Duke of Portland on 27 July 1901 and the church was consecrated on 23 May 1903 by Dr Ridding, Bishop of Southwell. The first Vicar was the Revd T. B. Lawson.

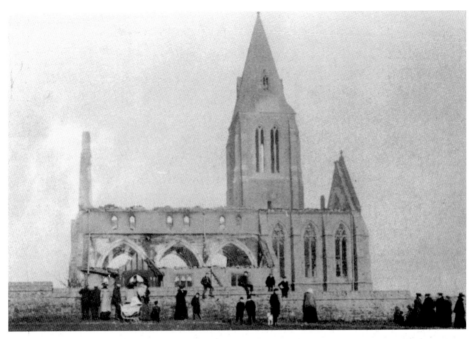

Annesley All Saints' Church in ruins. Much of the church was destroyed by fire on 17 January 1907, the night after St Wilfrid's had been the target of an arson attack.

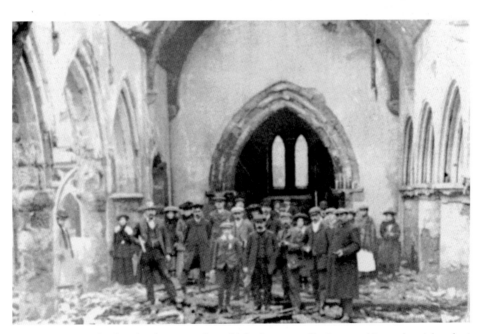

St Wilfrid's Church after the disastrous fire which almost totally destroyed it on the night of 16 January 1907. Such was the dedication and devotion of its parishioners, however, that it was duly rebuilt and reopened for worship in November 1908. Part of the original stonework can still be seen at the east end, and the tower and spire were largely unharmed.

One of the many yards off Church Street, Kirkby, before much demolition and modernisation took place. The pantiled cottages on the left (one of which at the time served as offices for estate agents E. and J. Lowe) have long since disappeared.

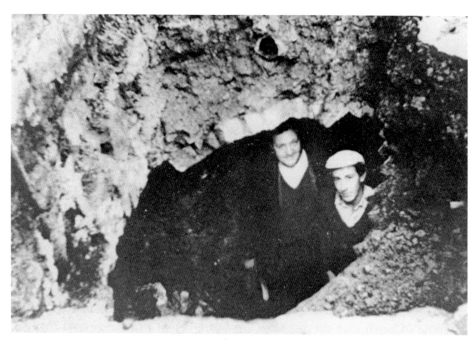

A secret passage? Legend has it that an underground tunnel led from the Duke of Wellington Inn to St Wilfrid's a hundred yards away, adding, mischievously, that it was used by the rector's butler as the opportunity occurred!

Taken from the Regent cinema roof, this photograph shows some of the many dwellings off Lowmoor Road before redevelopment.

A passageway behind some of the Lowmoor Road shops.

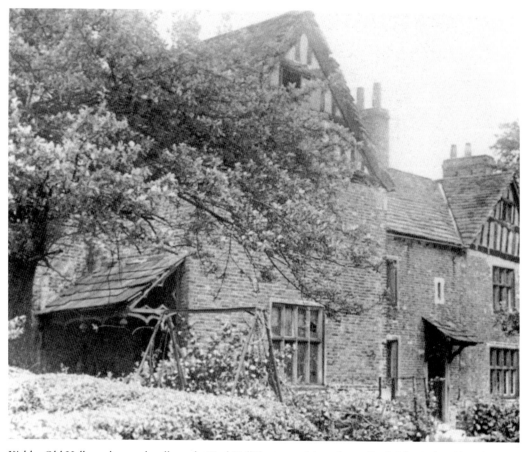

Kirkby Old Hall was known locally as the 'Red Hall' because of the colour of its bricks. It dated largely from the sixteenth century, although part of it is thought to be somewhat older. 'Fair Rosamund', mistress of Henry II, is said to have been born here. Sadly, the building was allowed to fall into a state of disrepair, making demolition inevitable.

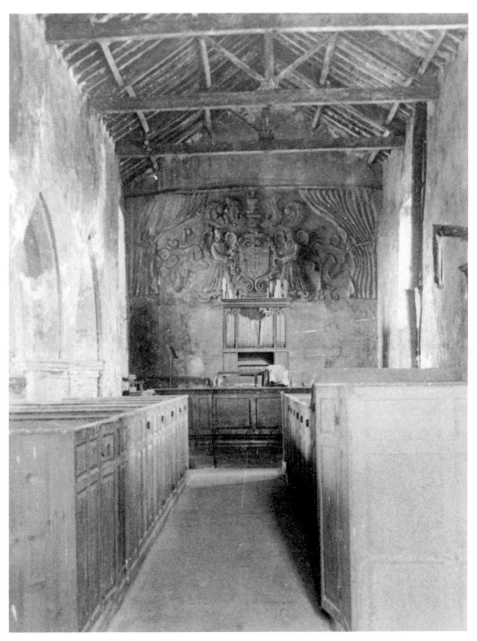

Interior of the old parish church, Annesley. The photograph shows (indistinctly) the 'Achievement' on the far wall, described by local historian Canon Frank Lyons as a 'remarkable work of art, redolent of the aristocratic age in which it was made'. In 1686 Lord Chaworth, thinking himself to be the last of his line, and knowing that his illegitimate son could not inherit his title, created the Achievement to pay tribute to a long line of ancestors going back to the Dark Ages; Lord Chaworth wanted his son to know the family history. Exposed to the elements for years in an increasingly ruinous church, the Achievement was removed in 1976, in a remarkable Conservation Society operation, to the present All Saints' Church about a mile away.

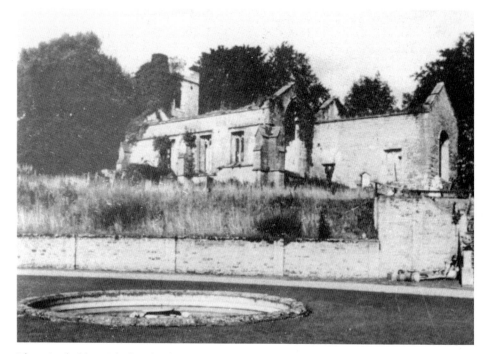

The ruined old parish church. The view above was taken from the lawn at Annesley Hall; that below is a striking shot of the tower. Note the chimney to the left of the arch. It was near the chimney, so it was said, that the squire's family sat in the days when heating was somewhat rudimentary.

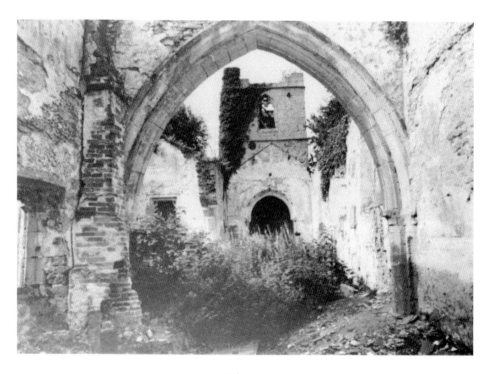

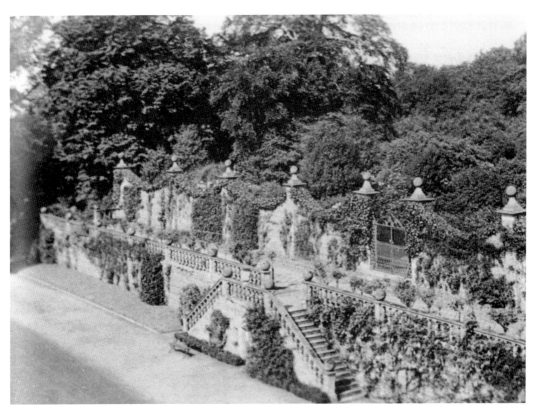

One of the elegant terraces at Annesley Hall. It serves as a reminder of the days of gracious living, but the terrace is no longer as shown. The doorway at ground level had a number of holes in it, supposedly made by bullets fired by Lord Byron, once a regular visitor, who was in love with beautiful Mary Chaworth, 'the bright morning star of Annesley'.

Acknowledgements

Our grateful thanks for allowing us to reproduce photographs in this book go to Kodak, Nottinghamshire County Cricket Club, and to the many people whose generosity over the years has supported the compilation of the Old Kirkby Collection.

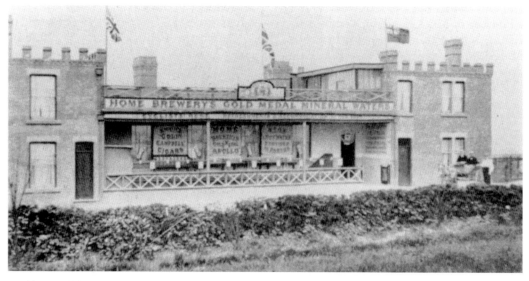

'Kirkby Castle', a restaurant long gone but still remembered by a few locals. It was severely damaged by fire in December 1927.